MANGA NOW!

HOW TO DRAW
MONSTERS & MECHA

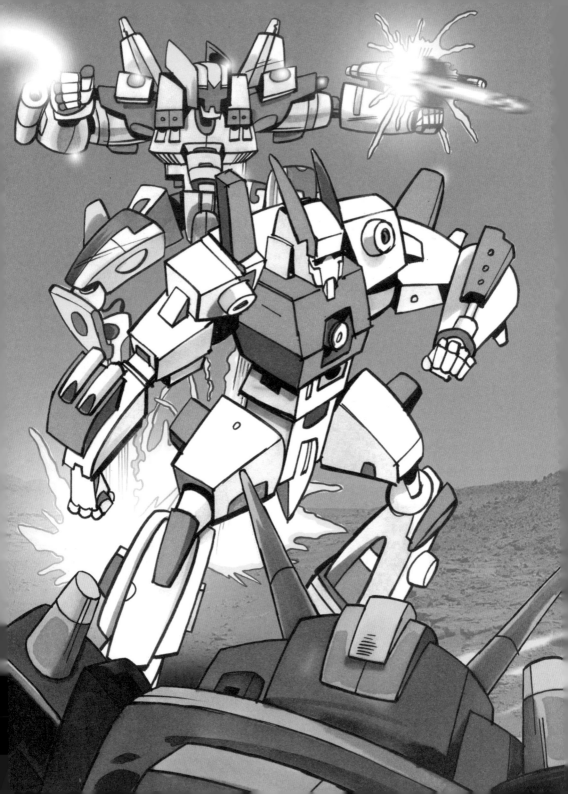

MANGA NOW!
HOW TO DRAW
MONSTERS & MECHA

Keith Sparrow

Search Press

DEDICATION
This book is dedicated
with love to Leo.

CONTENTS

INTRODUCTION

We all know about the monster under the bed or in the closet... don't we?! As Pixar's brilliant film, *Monsters Inc.* depicted so cleverly, humans have always lived with the idea of monsters lurking just out of view, waiting to jump out and scare us.

As a child I was warned of the mysterious 'bogey-man', who was looking to get his grubby hands on any young urchin who misbehaved. I'm sure you had your own version of the bogey-man who kept you awake at nights too. It was, of course, just a way our parents kept us on the straight-and-narrow; warning us to behave ourselves – or else!

The idea of a monster lies deep within all of us... the fear of our darker inner self escaping and leaving a trail of devastation in its wake. Sounds scary, doesn't it? Well, don't worry, because the other side of our feverish little minds is represented by the hero: a version of us that's bigger, stronger, and powerful enough to vanquish any threat that comes our way. This idea is made manifest in the mythical heroes and super-heroes of our cultures. In the case of manga, it is revealed through the mighty mechanical warriors known as *Mecha*.

As a species, we live in fear of our own mortality, and this fear translates into a longing for security and safety, which in turn becomes an urge to attack and vanquish anything we perceive as a threat. I like to think of the eternal struggle between good and evil (or in this case

BE A MANGAKA!

monsters and mecha heroes) as a kind of dance – the dark versus the light. In most cases the roles are clearly defined, but there are lots of examples where the roles are more ambiguous – Dr. Frankenstein's misunderstood monster, for example, or King Kong, the giant ape who meets a bitter end atop New York's landmark Empire State Building.

OW! YOU STEPPED ON MY TOES AGAIN!

SORRY – I'VE GOT FOUR LEFT FEET, YOU SEE...

A HISTORY OF MONSTERS IN MANGA

Monsters of one form or another have been around in stories since tales began. In ancient Japanese art and culture they often appeared as dragons, demons and malevolent spirits. It has been argued that humans began depicting these creatures in art in order to gain some level of mastery over them, as if by depicting them on paper, we could tame and ultimately vanquish them.

Perhaps surprisingly, one of the most famous monsters in Japanese culture started life not in manga, but as a live-action feature film. *Godzilla*, the dinosaur-like daikaiju (giant monster), first appeared in a 1954 film by Ishiro Honda, and has gone on to star in numerous films, television series, books, comics and video games. Often seen as a metaphor for the nuclear destruction visited upon Japan at the end of World War II, Godzilla is a complex mixture of menace, hero and victim, similar in a way to the giant ape made famous in the USA, King Kong. Disturbed from his (or possibly her – Godzilla has been depicted laying eggs!) undersea dwelling by man-made or natural disasters, he would head inland and leave a trail of devastation in his wake before eventually being driven back to the depths.

This nuanced and complex portrayal is typical of monsters in manga. The theme of becoming a monster to overcome other monsters is also common. In the case of the manga series *Devilman* by Go Nagai (1972), a teenager named Akira Fudo gains the power to transform himself into a demon when he acquires a mask which turns out to be an ancient fossilized demon skull. Overcoming the demonic nature of the mask through the purity of his heart, Akira uses the powers the mask bestows upon its wearer to combat the demon hordes which are threatening to overrun the earth.

Some monsters take near-human form. The idea of monsters that look like us is a particularly terrifying prospect, as it challenges the whole idea of what it means to be a human being, and hints at that dark inner-self we all possess. A good example is *Attack On Titan* (2009), by Hajime Isayama. It is a hugely popular manga and anime series set in a world where a dwindling human population is terrorised by gigantic humanoid creatures who appear to have no other purpose than to eat humans. Forced to live behind enormous protective walls, the remaining humans fight off attack after attack with the limited means at their disposal.

GODZILLA

With immense strength, armour-like skin and an eclectic and surprising list of other abilities, the famous Godzilla has often gone head-to-head with other giant monsters (known in Japan as *kaiju*) such as King Ghidorah, Mothra, Gigan and Mechagodzilla (exactly what it sounds like: a mechanical version of Godzilla!), and has even fought King Kong in a crossover movie.

A HISTORY OF MECHA IN MANGA

Godzilla can be seen as a metaphor for the destruction of Hiroshima and Nagasaki at the end of World War II, and by extension, the threat of destruction from outside. Seen in this light, the whole concept of mecha can be viewed as a symbol of Japanese empowerment and self-defence.

As early as 1943, the idea of a giant mechanical robot figure defeating the American enemy was portrayed in a cartoon in the magazine *Manga* by Ryuichi Yokoyama, called *The Science Warrior Appears In New York*, and the Western allies were repeatedly portrayed in manga as allies with the Devil. Following World War II and the American occupation of Japan, however, the mangaka (manga creators) began to embrace American ideas and culture. Among them was the young artist Osama Tezuka. Tezuka was hugely impressed with the ideas coming out of the Walt Disney Studio, and their influence crept into his manga work, ultimately leading to the age of manga as we know it today.

In 1952, Tezuka's manga *Tetsuwan Atomu*, or Astro Boy, kick started the mecha genre with the adventures of a nuclear-powered robot boy. It became a huge hit, spawning an anime series which became the first Japanese animation to be shown on US television.

The first mecha controlled by humans appeared in 1956, with *Tetsujin 28-Go*, by Mitsuteru Yokoyama. Tetsujin 28 was a giant robot controlled by a young boy. The idea of a human actually controlling the robot from the inside in a kind of cockpit, came with the arrival of *Mazinger Z* by Go Nagai in 1972, which pioneered the mecha genre as it is today, leading to hit series like *Gundam*, *Macross*, *Shogun Warriors*,

TYPICAL MODERN-STYLE MECHA, WITH LEAN ANGULAR SHAPES FOR SPEED AND VERSATILITY.

Escaflowne and *Evangelion*, as well as series which were developed into popular toy brands like *Transformers* and the *Mighty Morphin' Power Rangers*. In the *Power Rangers* television series, each episode usually featured the individual rangers coming together as a giant mecha, to do battle against an equally giant-sized monster or demon.

MONSTERS AND MECHA TODAY

Monsters and mecha clearly tap into some primal ideas, and their appeal goes from strength to strength with each new generation. Developments in computer-generated film technology have enabled mecha and monsters to be brought to life in spectacular fashion in recent blockbuster films such as the *Transformers* series, where benevolent alien robots called Autobots do battle with evil Decepticons; and *Pacific Rim*, where humans face attack from inter-dimensional kaiju, and create a series of giant mecha to fight them off. Even that most-loved of monsters, Godzilla, made yet another comeback in 2014 with a new eponymous film.

The fascination with monsters and mecha goes on. Whether it represents the eternal human struggle of good versus evil is arguable – but whatever the case, they certainly make exciting subjects to draw!

A MILITARY-STYLE WAR-BOT MECHA, WITH HEAVY ARMOUR AND MULTIPLE WEAPON SYSTEMS FOR BATTLEFIELD COMBAT DUTY.

SPACE TO WORK

A very important factor in drawing, and one that is often overlooked, is a comfortable working space. If possible, you should find a table or desk that you can use exclusively so that your things won't get moved about. Maybe a desk in your own room, or perhaps part of the family kitchen table that could be designated as your drawing area. Once you have a space, try to keep it clear, clean and tidy when not in use. Use containers to store your pens, pencils and markers... you could use mugs or old jam jars, for example. If you leave an unfinished drawing on your desk it's a good idea to cover it with a piece of paper to keep it clean. Some people prefer a flat desk, some a sloping desk like a draughtsman's table – this is a personal choice. I prefer a flat space, but you can buy small adjustable sloping desktops if that suits you better.

YOUR LIGHT SOURCE

While you're drawing, make sure there's a good light source nearby. Drawing can put a strain on the eyes, especially in dim light, so if you're not near a window, or you're working at night, use a desk lamp. Some artists use 'daytime' bulbs, which have a blue tinge and more closely resemble daylight.

WHERE TO SIT

You also need to ensure you have a comfortable seat. Many people have bad posture when they draw, often hunched over a desk for hours on end... this can have a negative impact on your drawing technique, not to mention giving you back pains as you get older.

BREAK IT UP

Take regular short breaks and get up and move about, gently stretching your back if you can. Taking a break from drawing is also important for your eyes – staring closely at a drawing for long periods of time can quickly lead to tired eyes, so changing your surroundings now and then is good for them, and will also help to keep your mind fresh.

MY CREATIVE ENVIRONMENT

Here's a photo of my drawing space, showing a variety of tools and equipment. Notice the drawers on either side for storing reference materials and other tools.

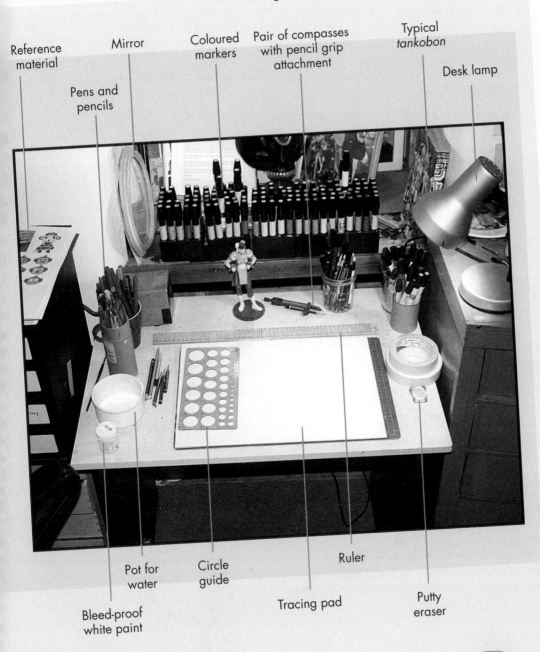

Reference material

Mirror

Coloured markers

Pair of compasses with pencil grip attachment

Typical *tankobon*

Desk lamp

Pens and pencils

Pot for water

Circle guide

Ruler

Bleed-proof white paint

Tracing pad

Putty eraser

A MATERIAL WORLD...

As for any other job, to get the best results you need the right tools. Those tools will vary from artist to artist, and what works for you may not work for the next person. So how do you choose? Simple: trial and error.

PENCILS

A pencil is an essential tool for any artist, but don't try to draw with a blunt pencil you found at the bottom of a kitchen drawer – invest in some quality pencils. There is a range of pencil grades from hard (H) to soft (B) – the hardest is 9H, through to the softest at 9B. In the middle you have an HB and an F grade (midway between H and HB). A very hard pencil gives a cleaner line but tends to cut into the paper and is not suitable for non-technical drawing such as manga. On the other hand, a very soft pencil can smudge easily and can quickly lead to a very messy sketch! The best place to start is in the middle, with an HB grade. This will give you a reasonably clean line but is soft enough to allow for some flexibility in your drawing. Use a softer grade such as a 2B or 3B to add some shading once you have the basic drawing in place. It's worth paying slightly more for a good-quality pencil, rather than the cheap ones you can buy in bulk. Don't be afraid to go to your local art shop and ask for advice on which brands of pencils to try. There are lots to choose from and it's worth trying a selection to find the one you're most comfortable with. You will be constantly sharpening your pencils, and inferior brands often fracture along the lead and become useless. Make sure you have a decent pencil sharpener – if possible get an electric one; you will be using this a lot, as a sharp point is essential to good drawing.

ERASER

As you work on your drawing you will sometimes need to erase a line or two. Make life easy for yourself by not pressing too hard when using your pencil… it's a lot easier to clean up a light drawing! Later, when you've inked your drawing you will also need to erase unwanted pencil marks, especially if you want to colour it.

Erasers are available in all shapes and sizes, but you should avoid novelty types as they can smear your work and leave lots of bits behind. Plastic and rubber erasers can also be quite messy and can damage your paper surface with heavy use. I tend to use putty erasers, which don't tend to leave any mess behind and are quite safe on paper. You can buy them in any high street art shop.

PAPER

Choice of paper is also important. There are lots of styles and colours: smooth, rough, white, off-white, and you should experiment with as many as you can. Local art shops may have some samples you can try – you could be a future regular customer to them so don't be afraid to ask. The paper you use will depend on how you want to finish your drawing and whether or not you want to colour it.

To start with I would suggest buying a cheap cartridge paper sketchbook to practise in so that you won't be afraid to make mistakes or take chances with your drawing. Cartridge paper is a very comfortable and strong surface and will take coloured pencils well if you wish to try those. If you intend to ink your drawing (using an ink-based pen or brush to finish off your pencil sketch) you should use a smoother, high-grade paper. You will find pads of suitable paper in your art shop, some actually branded as 'manga paper', which are good for clean linework, but any smooth surface paper will do. Marker or layout pads are very good if you intend to colour with marker pens, as many manga artists do.

Another option is to do your pencil drawing on one sheet of paper, then trace over the linework on a separate sheet, leaving you with a clean, pencil-free version to colour in. A desktop lightbox is very useful for this method.

INKING & COLOURING

When you're happy with your pencil drawing, the next stage is to ink and colour it. There is a multitude of ink pens, brushes and inks you can use – it's worth having a look in your local art shop, where you can usually try them out before buying.

Pens come in grades of nib thickness, from 0.1mm up to 0.8mm and above. A good starting point is a medium-size nib, such as 0.5mm. It's also worth thinking about how you will use different pens within your drawings: you might want to use a thicker pen for the outside line of a figure and for objects in the foreground, and a finer pen for smaller details or background objects, as this will give your drawing a sense of depth. As well as regular pens there are brush pens, which can be useful for lines of varying width – from very fine lines to broad brush strokes – or for putting in strong shadows. These are normally cartridge pens with a brush tip instead of a nib.

When you've inked your drawing, let it dry completely before erasing any unwanted pencil marks. You can colour your drawing using a number of different media, such as colour pencils, markers, paint, or on the computer.

Colour pencils

The simplest way to colour your drawing is with colour pencils. These are relatively cheap and come in an excellent range of colours. As with all things, it's well worth paying a little bit more for a quality set, and don't forget to keep a reasonably sharp point on them.

Markers

Probably the most common medium for budding mangaka is coloured markers. They come in a wide range of colours and shades of grey, and can be blended and combined to excellent effect. Most are double-ended, with a broad, wedged tip at one end and a thinner, rounded tip at the other. Some also have a third, fine-line tip. These markers can take a little getting used to but are very versatile. Their downside is that they aren't very practical for small details, as the colour tends to 'bleed' out from the point of contact with the paper surface.

Paint

Some artists like to use paint such as watercolour on their manga art. With a bit of practice this can be a lovely way to give your art a vibrant look. You must ensure you use a waterproof ink to do your linework, which should be drawn onto a smooth watercolour paper – use a desktop lightbox if you need to trace your outline.

White-out paint

Whichever method you use to colour your drawing, it's worth also having a small thin brush on hand with a pot of white bleed-proof paint – this is handy for cleaning up any linework mistakes or tidying up colour that has bled through the linework. Keep a pot of water nearby to wash your brush immediately after use. When paint dries on the brush it can be hard to remove without damaging the bristles.

Computer

If you're familiar with computer programmes such as Adobe Photoshop, you can achieve some fantastic results by scanning in your linework – or even drawing it straight onto the screen if you use a tablet – and colouring it in digitally. The advantage of this is that you can easily create special effects and gradients, as well as being able to edit and change your drawing. Scan your linework in at high resolution (at least 300dpi), clean it up, then increase your contrast to 100 per cent, adjusting the brightness as needed. Then you can select areas of your drawing to colour. It's a good idea to duplicate your linework layer in case you go wrong, and make sure you save at regular moments. You don't want to spend hours on a piece of artwork and then lose it if your computer crashes!

RULERS AND DRAWING AIDS

Sometimes you will need perfectly straight lines or neat curves in your drawing. Manga is renowned for its painstakingly accurate depiction of things such as streets, buildings and cars, so to get your drawing as accurate as possible you should have a clear, sturdy plastic ruler for straight lines, and a circle guide and small pair of compasses for curves and circles. All of these can be bought from stationery or art shops. Think about how big your workspace is and don't buy a ruler that's too long for practical use – if it's too long you'll find yourself always knocking pens off your board when you change angles – very frustrating! I find that a 30cm (12in) ruler is usually sufficient for most straight lines.

Circle guides are plastic templates with a variety of circle sizes cut out, but for larger circles you should use a pair of compasses. Remember not to press too hard into the paper with your point though – gently but firmly is the rule here. I prefer to draw curved lines freehand, but if you're not confident doing this you can buy plastic curve templates in a variety of shapes, or use flexi-curves, which can be bent to any degree of curve you want.

OVERCOMING FEAR OF A BLANK PAGE

The best thing about drawing your own manga, or drawing anything for that matter, is that YOU MAKE THE RULES! No one can tell you what you should or shouldn't draw: it's completely up to you.

The trouble is – as any self-respecting superhero will tell you – with great power comes great responsibility. If no one tells you what to draw, how do you know where to start? What I have learnt, is that the only way to conquer the fear of a blank space is to begin to FILL IT! Once you break the spell of an empty piece of paper you'll find it gets easier with every stroke of the pencil. Doodling is a very useful way to do this, and with doodling you can let your mind wander while you ponder the possibilities in front of you. Keep well away from the main area of the paper and limit yourself to the margins; all manner of ideas may actually evolve from the tiny marks you make.

Another way to combat the blank space is to draw random lines, shapes and curves in big swathes across the page. Keep it light enough to erase if need be, and once you've made a few marks you can begin to construct your image using those lines as a kind of very rough plan. Treat the blank space as an enemy in combat: treat it with respect and caution, but don't fear it and you won't go wrong.

MONSTERS!

The dictionary defines monster as 'a large, ugly, and frightening imaginary creature', which covers a huge variety of creatures! This part of the book is divided into sections on supernatural, bestial, insectoid, kaiju, and chibi monsters. Each section has some examples for you to try, which I hope inspire you to create your own!

Because they're imaginary, there are no rules to drawing monsters, but it's always good to think about what their individual attributes are, and if they have any unique powers or capabilities. To help get your creative juices going, I'll be providing a brief description of each monster, including a name.

Ready? Then 'Hajime!' as my karate sensei used to shout!

SUPERNATURAL

Look up the word supernatural in the dictionary and you'll see it comes from the Latin words *supra* (meaning 'above') and *naturalis* (meaning 'nature'), so the meaning can be described as something above or beyond what we know as natural or normal. As a type of monster it is probably the one we are most familiar with in literature and film.

The term covers all manner of magical, occult and mystical beings such as demons, vampires, werewolves, ghosts and monsters such as the golem. The original golem was a creature made of clay, brought to life in ancient Jewish legend, but his cultural descendants include legendary creatures like horror writer Mary Shelley's Frankenstein's monster and, more recently, Marvel Comic's jolly green giant known as the Incredible Hulk.

Supernatural creatures have been a staple diet of manga comics from the start, and demons and vampires play a major role in many popular titles. In this section we're going to look at the physical characteristics of some of these ever-popular monsters!

NNGRRONCK!!!

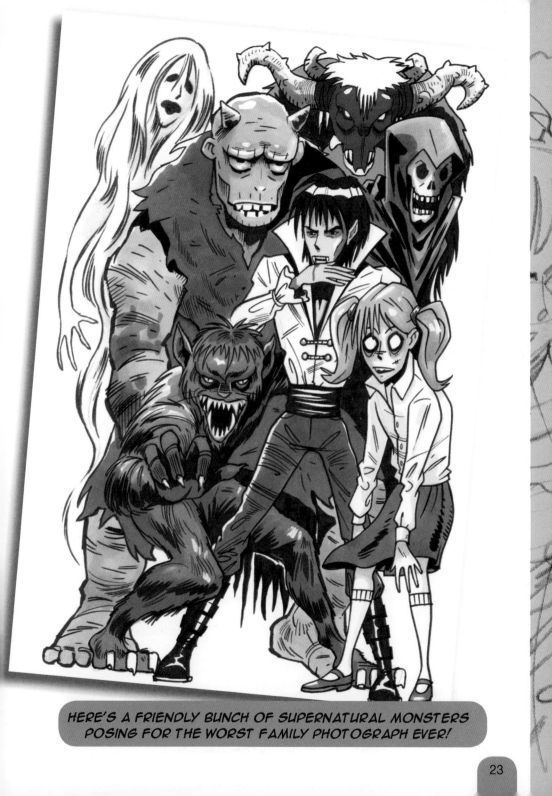

HERE'S A FRIENDLY BUNCH OF SUPERNATURAL MONSTERS POSING FOR THE WORST FAMILY PHOTOGRAPH EVER!

SUPERNATURAL FEATURES

Supernatural monsters may have basic humanoid features, such as eyes, nose and mouth, but you can inject a dose of fear-factor by altering and exaggerating the proportions as shown in these examples:

VAMPIRE

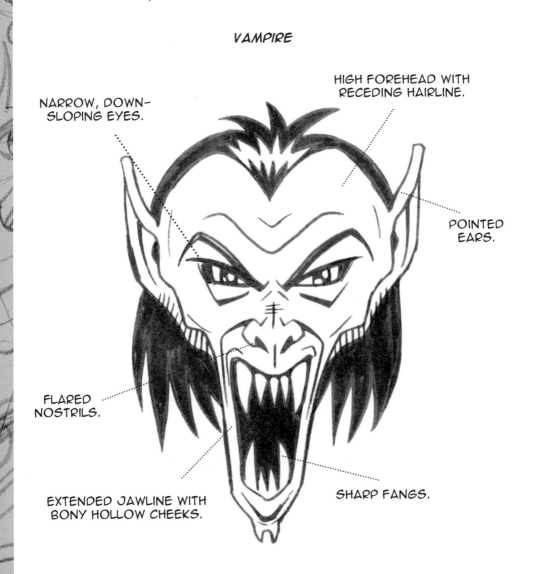

NARROW, DOWN-SLOPING EYES.

HIGH FOREHEAD WITH RECEDING HAIRLINE.

POINTED EARS.

FLARED NOSTRILS.

EXTENDED JAWLINE WITH BONY HOLLOW CHEEKS.

SHARP FANGS.

DEMON

LARGE HORNS.

NO HAIR.

HOODED, HEAVY-
BROWED EYES.

THIN ANGULAR
NOSTRILS.

THIN, WIDE MOUTH
WITH A HINT OF
SHARP FANGS.

BROAD NECK
MERGING WITH
SHOULDERS.

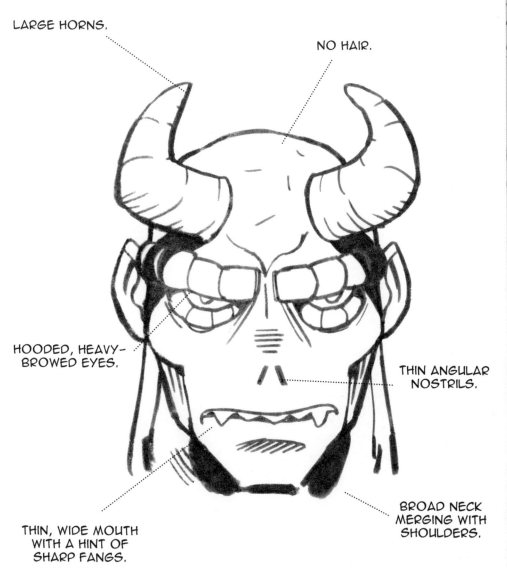

Werewolf

The concept of a half-human, half-animal hybrid has been used in many ways over the years, and one of the most familiar is the creature that appears on a full moon – the werewolf!

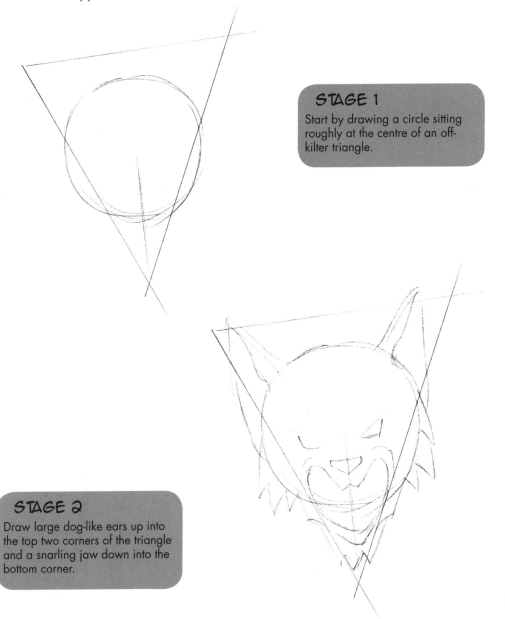

STAGE 1
Start by drawing a circle sitting roughly at the centre of an off-kilter triangle.

STAGE 2
Draw large dog-like ears up into the top two corners of the triangle and a snarling jaw down into the bottom corner.

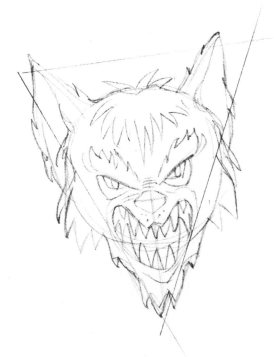

STAGE 3

Add some shaggy spikes of fur around the head and jaw, and above the eyes.

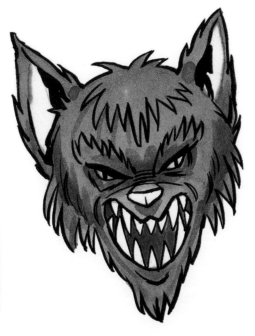

STAGE 4

Outline the head with black, then colour it with a rich brown for the fur and red for the mouth. Add a touch of yellow for evil-looking eyes.

Golem

A lumbering brute with little intelligence. No, not your dad – I mean this happy-looking fellow. Golems tend to be dim-witted and occasionally misunderstood, but you still would not want to meet one in a dark alley!

STAGE 1

Start with a circle, then add an angular block shape beneath.

STAGE 2

Add two heavy-lidded eyes near the bottom of the circle and a low, wide slit for the mouth.

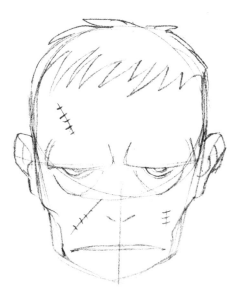

STAGE 3

Now draw some short, messy hair on top of the head and add a couple of stitched-up scars to the face.

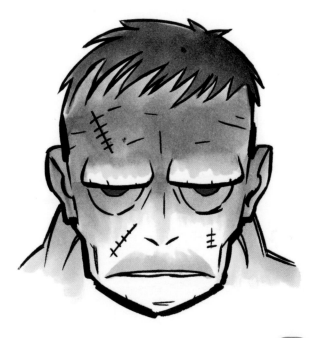

STAGE 4

Colour in muted shades of mauve and grey to give a deathly complexion. A hint of red in the eyes adds menace to his baleful stare.

Demon Lord

The undisputed big cheeses among supernatural monsters are the demon lords, who typically command hosts of minor demons that they rule with an iron fist... or claw!

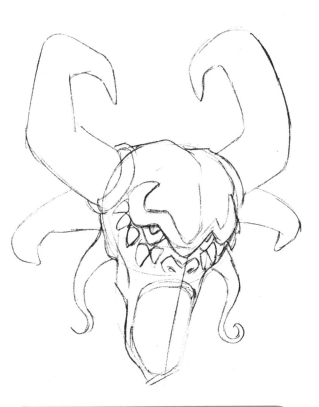

STAGE 1

Begin with a circle and draw an extended shape below, leading to a point.

STAGE 2

Add some large horns and appendages, with fearsome hooded eyes and a big gaping mouth.

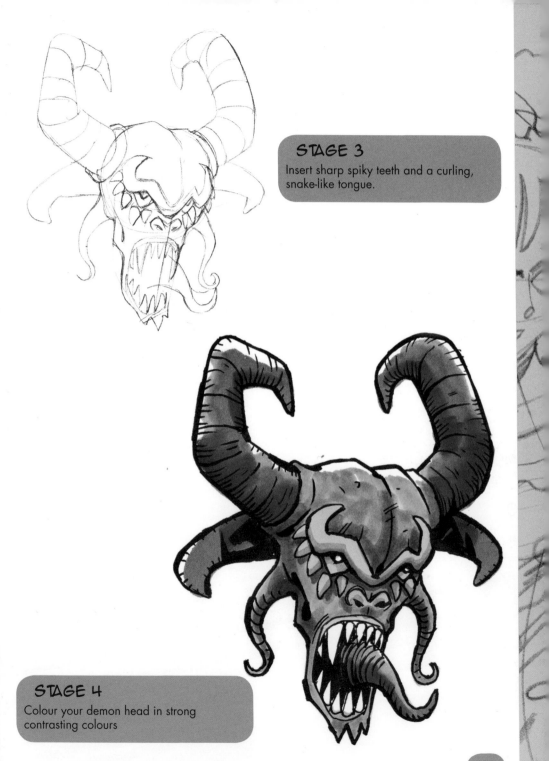

STAGE 3
Insert sharp spiky teeth and a curling, snake-like tongue.

STAGE 4
Colour your demon head in strong contrasting colours

Skeleton

Many supernatural monsters have risen from the dead, and this happy chap is not letting something like a lack of flesh stop his fun!

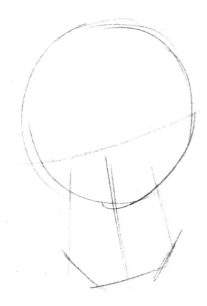

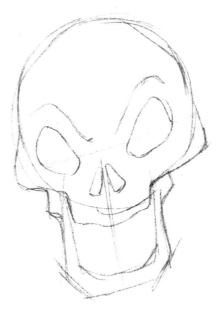

STAGE 1

Start with a circle sitting on an angular base which widens at the bottom.

STAGE 2

Add jutting cheekbones (and I do mean bones!), then draw in eye sockets, the nose aperture and a gaping jaw.

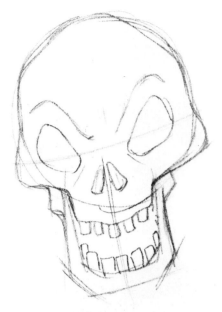

STAGE 3
Add some gappy, irregular teeth.

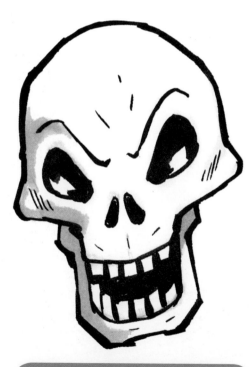

STAGE 4
Leave the skull white but fill in the mouth and sockets with black, and a touch of grey for the shadows.

Vampire

Here are two more supernatural monster heads to consider. First the ever-popular vampire, blood-guzzling undead legend and mainstay of numerous books, films, and – of course – many a manga title.

Today, vampires are usually portrayed in either sex as sensuous, alluring characters. Our female vampire here has the typical dark, lustrous hair, heavy-lidded eyes and ghastly pale complexion of a vampire. Two small fangs give away her true nature. If she invites you round for supper, make sure you are not the dessert...

STRONG REDS SUGGEST BLOOD AND COMPLEMENT THE BLACK AND WHITE SCHEME.

PIERCING GREEN EYES.

GLOSSY HIGHLIGHTS ADD A SEDUCTIVE, GLAMOROUS AIR.

SUBTLE PURPLE AND LILAC TONES HELP ACCENTUATE THE IVORY SKIN.

Zombie

While we're on the subject of dinner, here's another charmer who likes nothing more than a healthy human dinner. In fact that's all he likes! With a totally vacant mind, indicated by his almost empty eyes, the zombie is usually looking well past his sell-by date. Bits of skin are hanging off his unhealthy green-tinged face, and his mouth shows distinct traces of his last meal.

Zombies are notoriously hard to kill. Having no emotions to speak of and a total lack of sensitivity to pain, they keep coming until the very end.

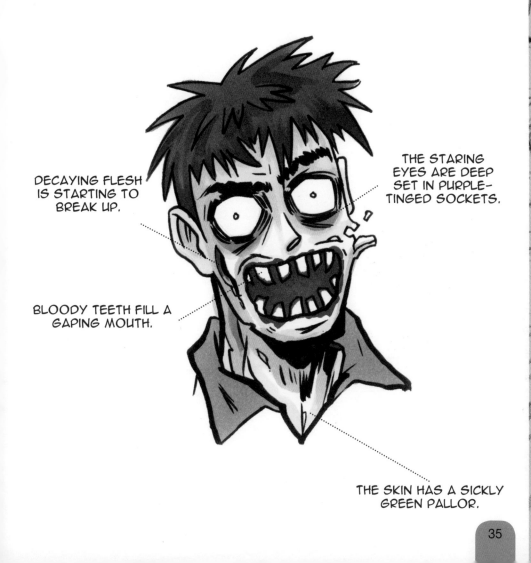

DECAYING FLESH IS STARTING TO BREAK UP.

THE STARING EYES ARE DEEP SET IN PURPLE-TINGED SOCKETS.

BLOODY TEETH FILL A GAPING MOUTH.

THE SKIN HAS A SICKLY GREEN PALLOR.

SUPERNATURAL APPENDAGES

Supernatural monsters often have appendages which relate directly to creatures found in nature, so it's good to have an encyclopedia or reference book on hand for inspiration. Here are three common appendages which are borrowed from nature!

CLAW
A typical claw-type hand can be based on the feet of a small bird, with bony fingers and prominent knuckle joints.

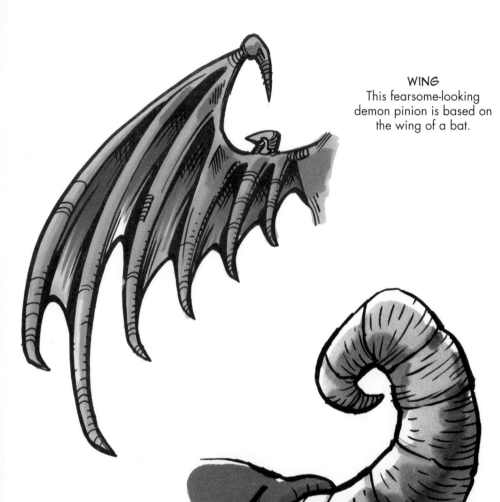

WING
This fearsome-looking demon pinion is based on the wing of a bat.

HORN
No self-respecting demon would be seen around town without an impressive set of horns. This example is inspired by the horns of a ram.

Fangs

A gaping maw full of ferocious-looking teeth is a common sight in supernatural monsters.

STAGE 1

Start with an oval on its side, then add a vase-shaped bottom area.

STAGE 2

Add thick, uneven lips and two rows of long pointed teeth. Draw a pointed tongue nestling in the centre of the mouth.

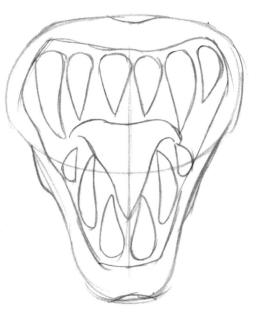

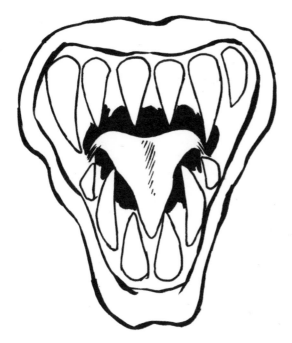

STAGE 3

Line in with an irregular outline, adding a slight dip to the top and bottom of the lips. Put some solid black around the base of the tongue for depth.

STAGE 4

Colour in pinks and reds, and use a pale warm tint on the fangs.

39

Demon lord helmet

More an accessory than an appendage, but no self-respecting demon lord can be without horns. If he does not have any of his own, he might opt for a helmet like this one.

STAGE 1

Start with a circle sitting on a cup shape below. Draw a central opening leading up to a mask-shaped eye-space.

STAGE 2

Add large horns and fin-shapes to the top and sides of the helmet.

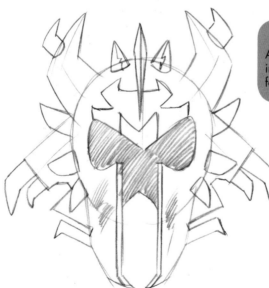

STAGE 3

Add some smaller horns and indicate a pattern on the forehead space.

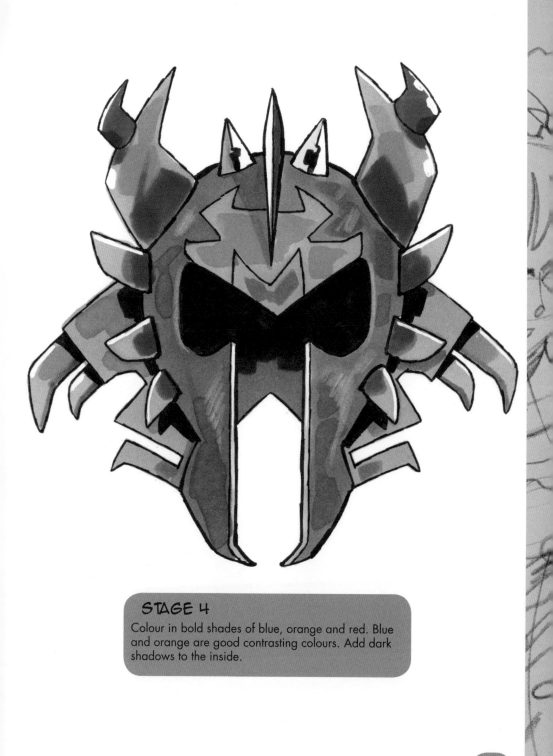

STAGE 4

Colour in bold shades of blue, orange and red. Blue and orange are good contrasting colours. Add dark shadows to the inside.

Flaming head

Who needs a hairdresser with a head like this?

STAGE 1
Start with a circle and taper it down to a sharp point as shown. Add a neck sloping away to bottom right, and a doughnut-shaped collar.

STAGE 2
Add sharp, hawkish features with pointed ears, and a shaggy fur outline to the collar. The face is at a three-quarter angle looking away to your left.

STAGE 3
Line in black and add some flames licking around the head.

STAGE 4

Colour the flames in yellow, getting lighter at the edges. Use a cold grey on the face and a dark green for the collar.

Leech hair

Like Medusa, the famous gorgon of ancient Greek legend, hair can sometimes have a life of its own!

STAGE 1

Start with a simple female head, with heavy-lidded eyes and arched eyebrows

STAGE 2

Draw a mass of writhing tentacles sprouting from her head. Using a leech as inspiration, finish the ends with circular mouths full of sharp teeth

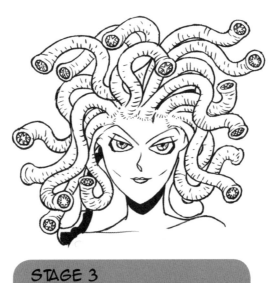

STAGE 3

Ink your drawing with black pen.

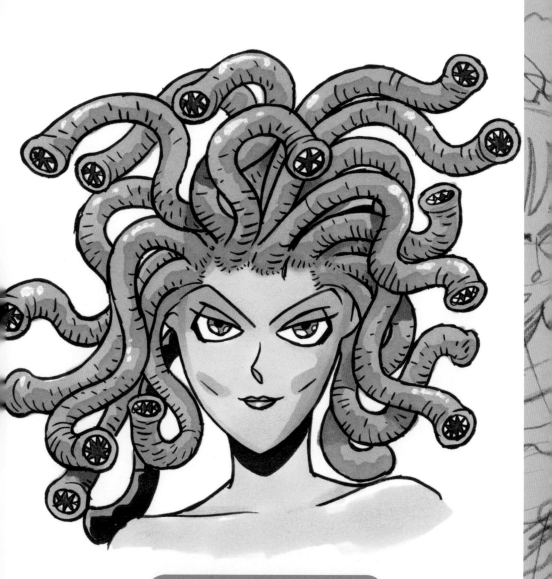

STAGE 4

Colour in the hair mauve with red mouths, and use blue for the face. A spot of orange in the eyes adds contrast.

SUPERNATURAL POWERS

Supernatural creatures can have a variety of suitably otherworldly powers, which they use to strike fear and terror into the hearts of humans.

SUPERHUMAN STRENGTH

Demons, vampires and troll-like creatures can be fiendishly strong, able to lift huge weights – like this rock-bearing troll.

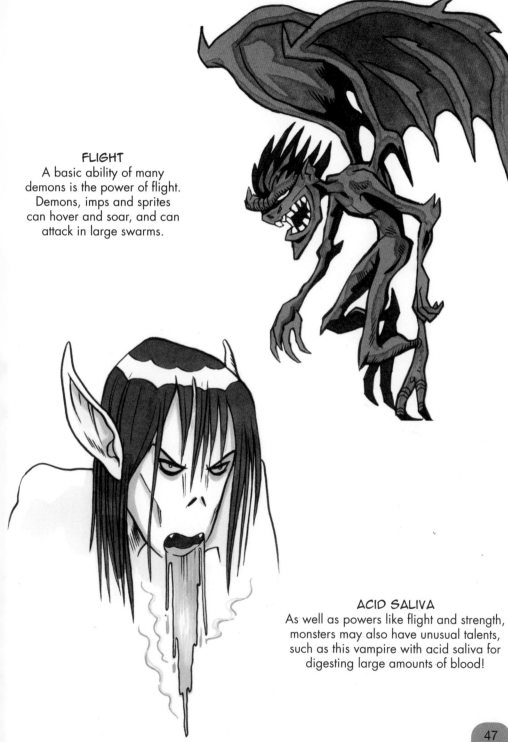

FLIGHT
A basic ability of many demons is the power of flight. Demons, imps and sprites can hover and soar, and can attack in large swarms.

ACID SALIVA
As well as powers like flight and strength, monsters may also have unusual talents, such as this vampire with acid saliva for digesting large amounts of blood!

47

Sorcery

Magical powers are very common in supernatural tales of witches, warlocks and sorcerers. Here is a sorceress casting a spell.

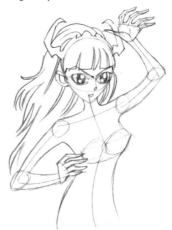

STAGE 1

Sketch a wireframe female figure with her left arm raised above her head.

STAGE 2

Flesh out the arms and torso, then add some long flowing hair with a fringe and topped with a head-piece.

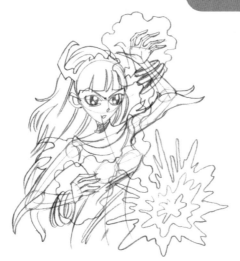

STAGE 3

Add some details to the robe, with sleeves slashed at the elbow, and some bangles. Draw rippling energy around the hands and joining down to form a magical burst.

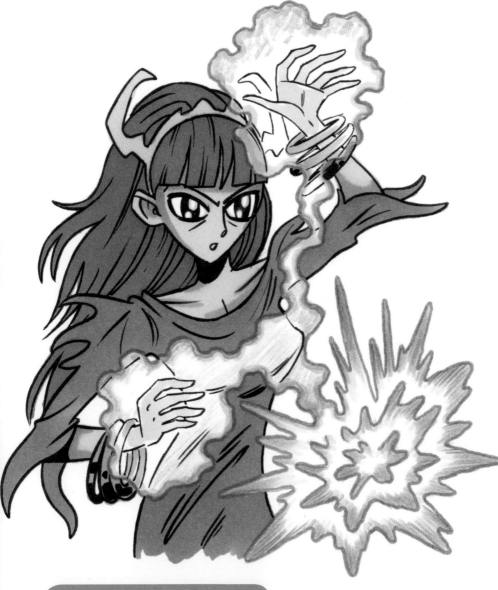

STAGE 4

Colour the hair lilac, and the head-piece yellow. Add flesh tones and make the dress blue, using lighter tones within the energy burst.

Eye beams

Try giving your monster searing eye beams for a shocking surprise.

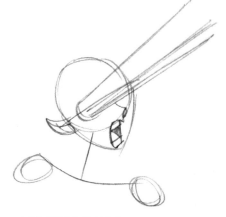

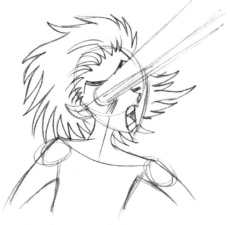

STAGE 1

Start with a simple wireframe head and shoulders. The head is tilted back with the force of the beams, so the ear is lower than the eye level.

STAGE 2

Flesh out the shoulders and add thick spiky hair swirling around the head.

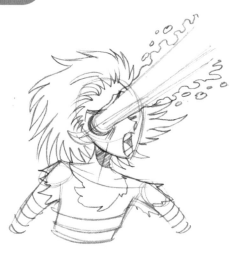

STAGE 3

Add a tattered, striped top, and some rippling spots of energy along the line of the beams.

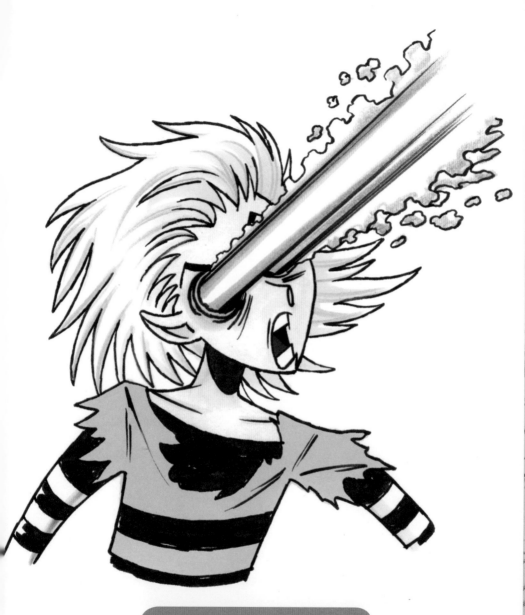

STAGE 4
Use a pale grey for the skin, and light blue shading on the hair. Outline the beams with strong pink, leaving the centre white.

Flame breath

Like the dragons of legend, this totemic demon
can unleash a burst of fiery, flaming breath!

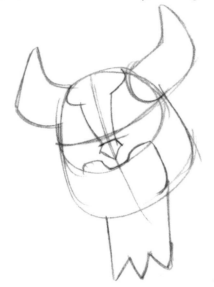

STAGE 1

Sketch the demon head as an upturned
bowl-shape, with two large horns and a
dropping jaw section.

STAGE 2

Add smaller horns, some
facial features and some
fan-like collar pieces. Draw
a burst of flame erupting
from the mouth.

STAGE 3

Add some fearsome and primitive-looking martial markings to the armour plates.

STAGE 4

Now line in black, and colour with dark grey, red, yellow and white. Outline the flame in red, with yellow at the outer edges.

EXAMPLE SUPERNATURAL MONSTERS

Demon warrior

Demon warriors are among the most formidable supernatural fighters. They are the foot soldiers of the demon king, and they need to be tough. Let's look at a typical example:

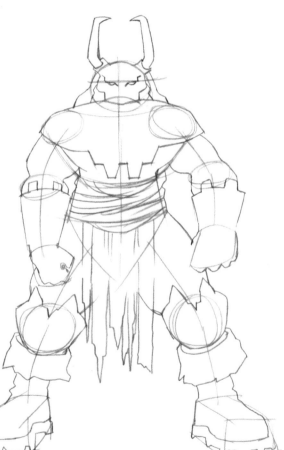

STAGE 1
Rough out a wireframe figure with a broad, flat head and torso.

STAGE 2
Add facial features and horns, then bulk out the frame, adding armour, gloves, boots and a loincloth.

STAGE 3

Draw bony wings and a studded mace in the demon's hand. Add studs to the armour and gloves, and a chain to the chestplate.

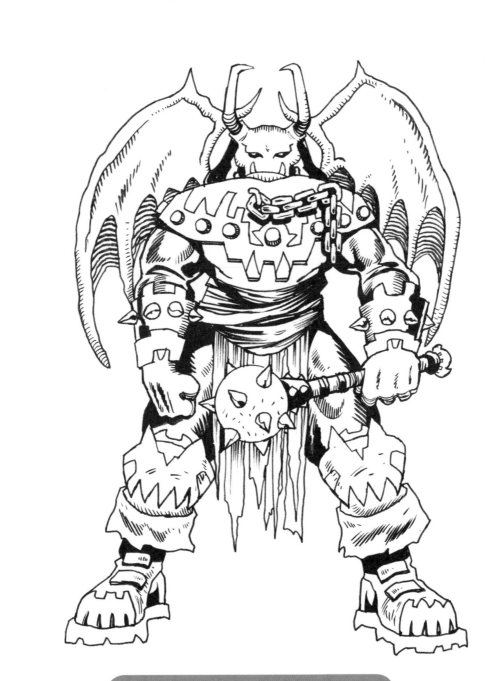

STAGE 4
Line in black with strong shadows, adding patterned
detail to the armour, knee-guards, boots and wings.

WINGS FOR SURPRISE
AERIAL ATTACK AND
FAST MOVEMENT.

THICK BODY ARMOUR WITH
CHAIN FOR ATTACHING
EXTRA WEAPONS.

PRIMITIVE
WEAPON
SUCH AS
SWORD, AXE
OR MACE.

HEAVY-DUTY
STUDDED
GAUNTLETS FOR
PROTECTION.

KNEE
GUARDS

ALL-TERRAIN
BOOTS.

LOINCLOTH FOR
FREEDOM OF MOVEMENT.

STAGE 5

Use brick red to colour in the body; grey and yellow for the
tunic, gloves and knee-pads; and mauve for the wings and
boots. Use a pale yellow ochre on the waistband and loincloth.

Nightstalker

Here's a real eye-catcher – the nightstalker loves to stalk her victims through their dreams. She wears the skulls of her victims as hair decorations.

STAGE 1

Begin with a small circle with an extended jawline, sitting on a large oval body. Add arms and two-jointed legs – a bit like a chicken!

STAGE 2

Flesh out the body, making the waist very thin and upper body very large. Add rows of mandibles around the mouth and three eye-sockets with long lashes.

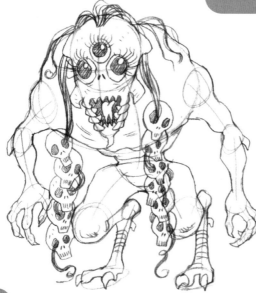

STAGE 3

Draw some long strands of hair woven down through a series of skulls and shade in the eyes solid black, leaving a white highlight.

STAGE 4

Ink in black with strong shadows around the waist, and colour the body green with brighter green on the mandibles and bright red hair. Use pale mauve shadow on the edges of the skulls.

Wraith

Spirits, ghosts and wraiths can pass through walls and other solid substances due to being immaterial. They can also be an unwelcome and melancholy presence around the place.

STAGE 1

Start with an oval shape drawn vertically, and draw a curving continuous line down through the spine, ending in a loose coil at the bottom. Add arms, one raised, one down.

STAGE 2

Flesh out the top half and taper the lower half away as shown. Keep the head in a vague, liquid form, without any definite shapes. Add long wavy hair.

STAGE 3

Starting at the shoulders, add flowing strands of fabric and short-length flared sleeves. Draw more long hair behind the figure and shade in the eyes.

STAGE 4

Line in with bright or pale blue. This adds a look of transparency to the figure. Use soft, quick strokes of pale blue to fill out the shape, and add some pale grey to the hair.

Rock troll

Trolls are generally pretty bad-tempered things, and this spiky
rock troll is even more unpleasant than most.

STAGE 1

Draw a broad-shaped wireframe
body with its left leg bent at the
knee. Draw the upper arms to the
elbow joints.

STAGE 2

Add a spread right hand and a clenched fist left
hand, with only three fingers and toes for simplicity.
Flesh out the arms, legs and torso, and add a large
monobrow and open mouth to the head.

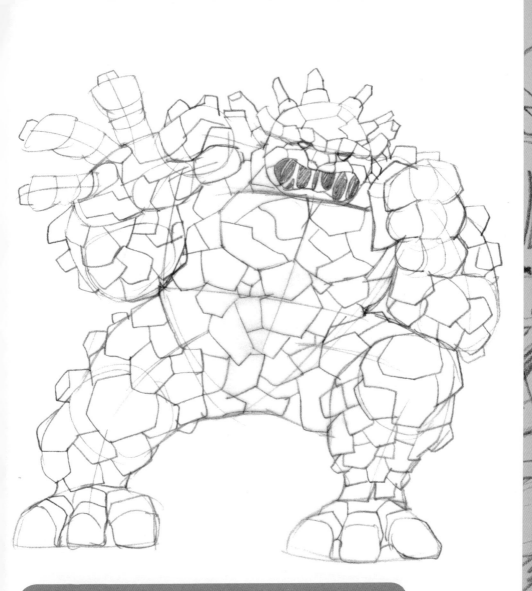

STAGE 3
Cover your figure with irregular rock shapes, adding extra bumps and protrusions around the head and limbs.

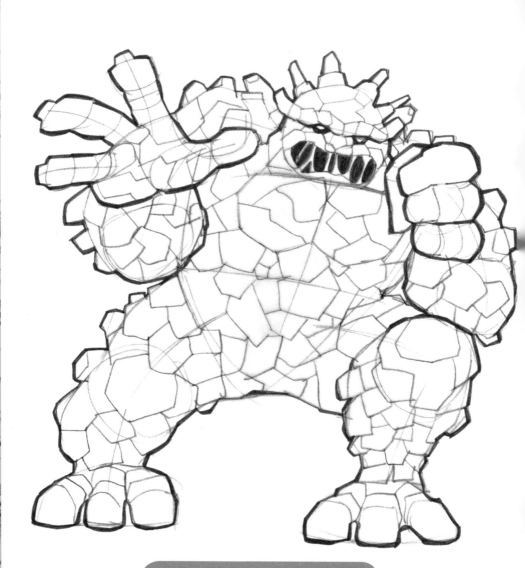

STAGE 4

Outline the troll in heavy black line and fill in the mouth with saliva strands as shown. Keeping your outline an irregular width makes your character even more rocky.

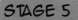

STAGE 5

Colour all over with a medium grey, then work in shading with a darker grey. Add some black shadow areas and white painted highlights using bleed-proof paint. Use a pale mauve/grey to indicate a shadow on the ground, which will give your figure a sense of weight.

BESTIAL

The world around us is full of a bewildering array of beasts in every size, shape and colour you can possibly imagine – and probably a few you can't! This abundance of natural diversity can be a fantastic source of inspiration, and for a mangaka looking to create some amazing creatures it can provide the perfect starting point for your drawing.

Mutants are also covered in this section. The word 'mutant' can be best described as a creature or organism which has undergone a genetic change, either by hereditary transmission (i.e. from parent to offspring) or via a mutagen (transforming agent) like radiation for example.

A famous example of this type of effect in manga/anime is the world-famous *Pokémon* brand. Created by Satoshi Tajiri in 1996 as a video game, pokémon (or 'pocket monsters') are creatures which mutate through experience and combat into stronger, more powerful versions of themselves.

You can use this principle as a starting point to draw some pretty scary monsters of your own! Think of an everyday creature and try and mutate it into a scarier version of itself.

In this section we are going to look at mixing and matching the features and characteristics of some familiar animals to create something unfamiliar and unsettling. Combining animal features and parts plays with our sense of security in the world around us, and can create an uneasy sense that something isn't quite right.

THIS GROUP OF IMAGINARY BEASTS USES PHYSICAL CHARACTERISTICS OF REAL ANIMALS LIKE GORILLAS, BATS AND CAMELS, BUT WITH GHASTLY TWISTS!

BESTIAL FEATURES

Your monster can be based on any type of real-life beast. The best way to start is to get yourself a big encyclopedia of animals. Of course, you can also look online for animal reference but it is more convenient to have a book beside you while you draw – that way you can open pages at random and get mix-and-match inspiration.

Here are a few examples of features sported by some real-life creatures, which you could adapt and use on a monster.

SNAKE TONGUE

WET, GLOSSY SURFACE.

SINUOUS FORKED END.

RHINOCEROS HORN

SHARP HIGHLIGHTS SHOW SMOOTH TEXTURE.

THICK, LEATHERY SKIN.

CROCODILE EYE

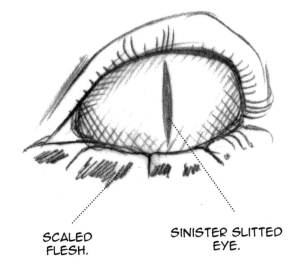

SCALED
FLESH.

SINISTER SLITTED
EYE.

CRAB FACE

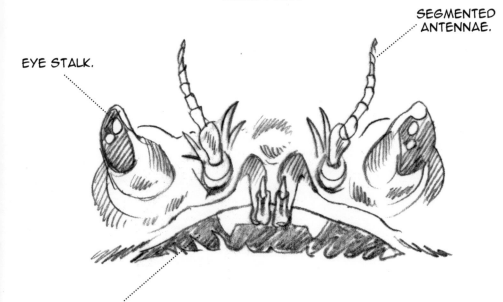

SEGMENTED
ANTENNAE.

EYE STALK.

MOUTH FILLED WITH UNEVEN
JAGGED 'TEETH'.

Elecat

Let's start with a monster combination of elephant and cat! Part of the fun is naming it, so we'll call it an 'elecat'. See what I did there?!

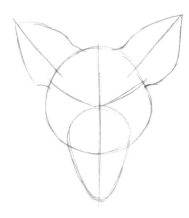

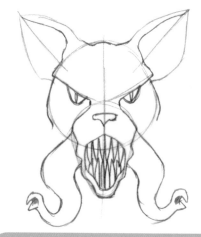

STAGE 1

Begin with an irregular circle, and add some large ear shapes and an upside-down pear shape for the snout.

STAGE 2

Add some mean-looking eyes with thin vertical pupils like a cat's eyes. Draw a mouth with long sharp teeth, and add a small cat's nose, then two small elephant trunks on either side of the mouth.

STAGE 3

Next draw two tusks coming from the cheeks, and some cat's whiskers snaking out on either side.

STAGE 4

Ink your head using lots of small lines for shading, suggesting an elephant's wrinkled skin. Colour in grey with a hint of mauve shading, and bright green cat's eyes. Leave the tusks white with pale shadows.

Badgerex

A distinctive feature of a lion is its shaggy mane. When you put it on a badger and add zombie-style eyes it looks fearsome!

STAGE 1

Start with an irregular circle, with a low eyeline, two small ears and two long curving shapes below.

STAGE 2

Add some eyes, two rows of small, sharp teeth, then draw in a broad stripe area vertically on the head, finishing at the top with a spiky clump of fur.

STAGE 3

Add a large shaggy mane around the head, making it bigger at the sides and bottom. Shade in the black areas on the face and add some horizontal crease lines across the snout.

STAGE 4

Ink the head and colour in dark grey and an off-white shading on the mane edges. Fill in the open mouth with a deep red.

Rhinorilla

Gorillas and apes are already pretty fearsome-looking. If you add the horn of a rhinoceros and an armoured jaw, they become even more so.

STAGE 1

Draw a broad, upside-down bowl shape with handles on either side, and bisect it vertically and horizontally.

STAGE 2

Now add a large rhino horn with an armoured brow and bottom jaw. Draw a small ape-like nose and some sharp teeth, then add detail to the ears.

STAGE 3

Ink your sketch with lots of solid blacks underneath the brow and chin, and as shadow under the horns. Fill in the rest of the head black, leaving a thin white highlight on top of the head for contrast.

STAGE 4

Colour with muted beige and browns on the ape parts, and cool grey on the horns, chin and brow.

EXAMPLE BESTIAL MONSTERS

We've covered some horrible heads by combining parts from different animals – now let's see how giving the beast a body can make your monster really scary! Whether your beast is a pure-bred pedigree monster or a mutant terror, these bestial monsters will show you how to get started exploring the natural world for ideas.

Mutant emu

Imagine an emu. What makes it an emu? It doesn't fly, so wings are not needed, but it has long bald legs for fast running, and a big ball of feathers for a body. Oh, and a beak... or is it a bill? Something for eating anyway! That's all you need to start.

STAGE 1
Start by drawing a circle with a cone shape extending from it. Add two wireframe legs, bent at the knee.

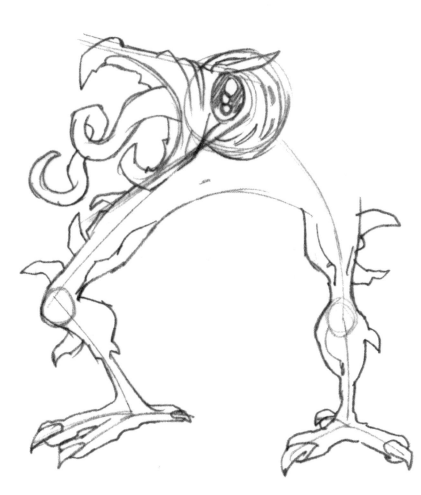

STAGE 2

Sketch a sharp beak point with a twisted tongue protruding. Add an eye surrounded by skin, and flesh out the powerful bony legs with random barbs and clawed toes.

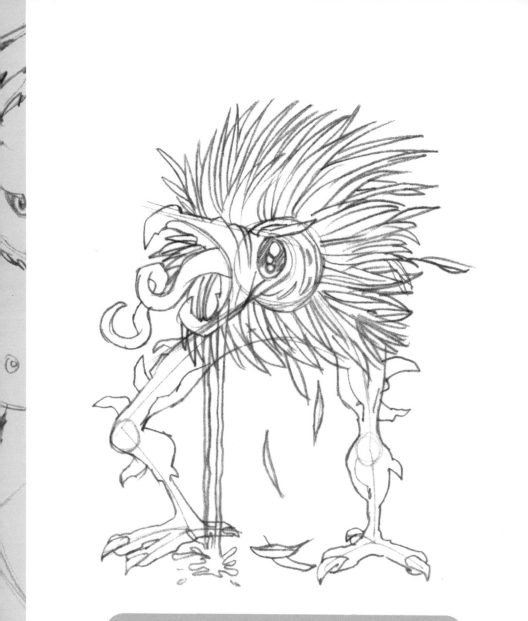

STAGE 3

Add a profusion of feathers for the body, and some strands of saliva dripping to the floor. Add some odd stray feathers to help to bring the figure to life, by indicating movement.

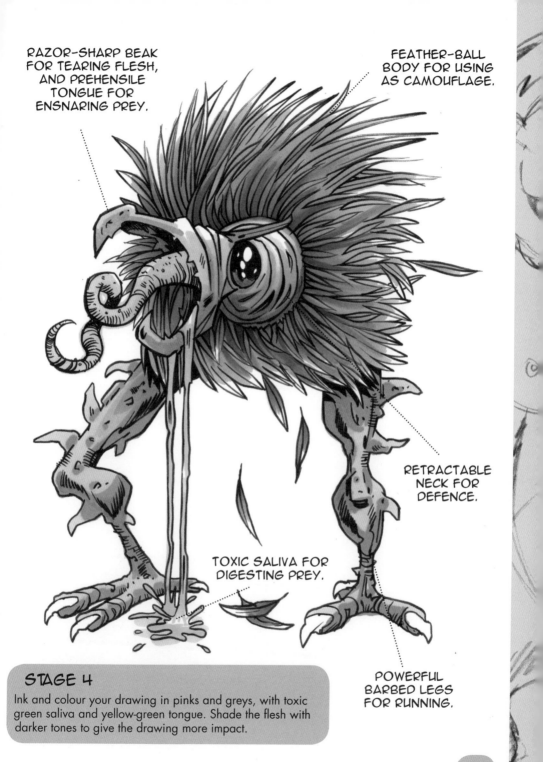

RAZOR-SHARP BEAK FOR TEARING FLESH, AND PREHENSILE TONGUE FOR ENSNARING PREY.

FEATHER-BALL BODY FOR USING AS CAMOUFLAGE.

RETRACTABLE NECK FOR DEFENCE.

TOXIC SALIVA FOR DIGESTING PREY.

POWERFUL BARBED LEGS FOR RUNNING.

STAGE 4

Ink and colour your drawing in pinks and greys, with toxic green saliva and yellow-green tongue. Shade the flesh with darker tones to give the drawing more impact.

Tracker fox

A low-level mutation of a common fox, the tracker fox has been genetically altered to become a still more lethal and fearsome carnivore...

STAGE 1
Draw a three-pronged shape for a head, muzzle and two large ears, then draw two curving lines down for the front legs, ending in rectangular blocks for the paws. Indicate the spine and hind quarters with two curving lines.

STAGE 2
Flesh out the body and paws, and add some features to the head, with narrow eyes under bushy eyebrows, and a long thin mouth with a row of sharp teeth. Tuck the lower part of the rear leg under the thigh so the hind legs appear mid-pounce.

STAGE 3

Add claws and a curving, bushy tail. Bring the tail up and behind the body to suggest the compression of a mid-pounce movement. The tips of the tail and ears are white on a fox, as is the chest, so indicate some shapes in these places.

STAGE 4

Ink and colour your drawing. To make it clear the fox is mutated, make it a vibrant mauve. Use a darker lilac to add some shading areas. The lower legs on a fox can be a darker grey, so use that colour here, and on the eyebrows as well.

Fragger

Take a cute little tree frog and make some minor adjustments...
like an extra eye, gnarly teeth and no front legs!

STAGE 1

Start with a lemon shape, and draw a wide mouth in the lower half and a rough circle in the top half. Draw a long curling tongue dropping down.

STAGE 2

Add two muscled jumping legs, crouched with spread toes and large sucker tips.

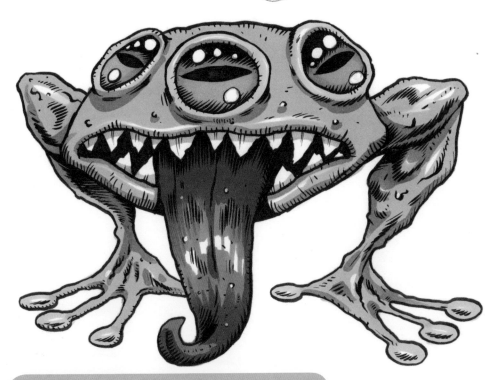

STAGE 3

Draw three large eyes on the centre and sides. Make the pupils a horizontal slit and add highlights. Then draw rows of jagged teeth across the mouth area.

STAGE 4

Ink and colour in bright greens, pink/red and yellow, with shading in darker tones. Leave some white highlights on the legs and round the lip areas.

Four-horned golden ox

A humble beast of burden can easily become a snorting, bug-eyed terror...

STAGE 1

Start with a small horizontal oval inside a larger vertical oval, and draw a vertical line in the centre.

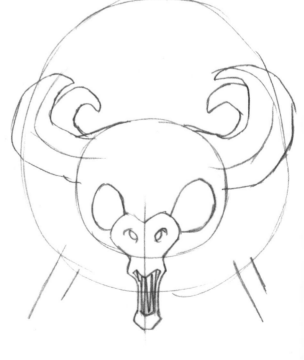

STAGE 2

Add four curving horns, then draw an extended snout with long teeth and topped with two large oval eyes. Draw four short diagonal lines for leg position.

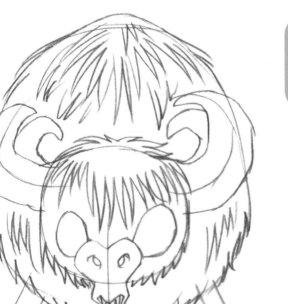

STAGE 3

Draw a long-haired shaggy body with a slightly protruding hump, and add some more hair to the head, with a long fringe.

STAGE 4

Then add four short muscular legs with hoof, shade in the eyes leaving a white space at the bottom and four highlights in decreasing size. Draw two jets of steam coming from the nostrils.

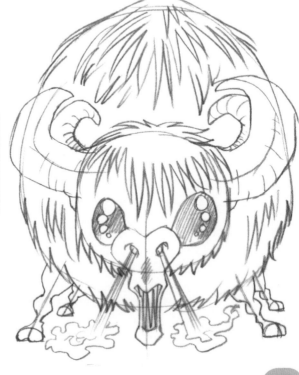

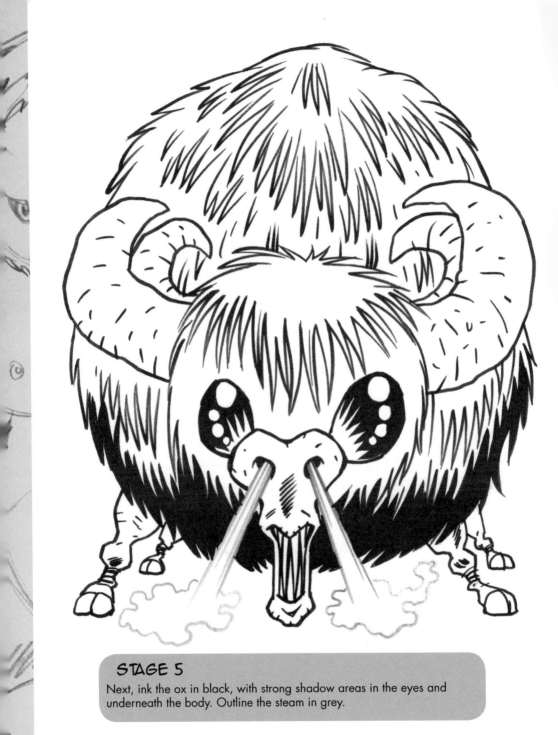

STAGE 5

Next, ink the ox in black, with strong shadow areas in the eyes and underneath the body. Outline the steam in grey.

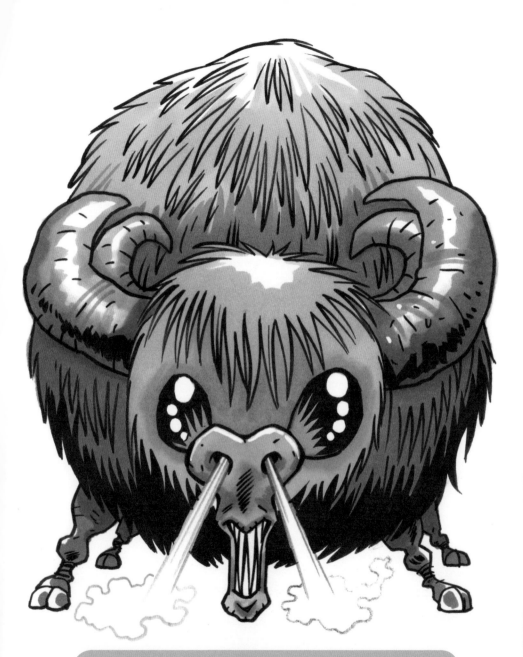

STAGE 6

Now colour the horns and snout in grey, with a hint of mauve. Leave some white highlights on the horns for extra shape. Colour the fur in strong yellow and pale sepia, getting darker as you get to the bottom. Fill the eye highlights in bright blue for contrast.

Fire bear

Mutations don't need to be biological or realistic. Try some more fantastical mutations, like this blazing bruin.

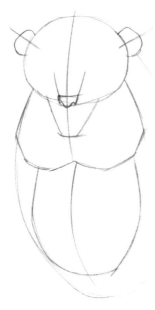

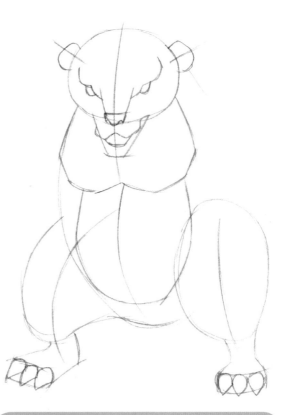

STAGE 1

Sketch out an oval head shape with areas for nose, ears and jaw. Underneath, draw a breast and stomach area.

STAGE 2

Draw two legs with large thighs and flat, clawed feet. Bears have a low centre of gravity and the legs need to carry a lot of weight. Add a mouth and slanting, narrowed eyes.

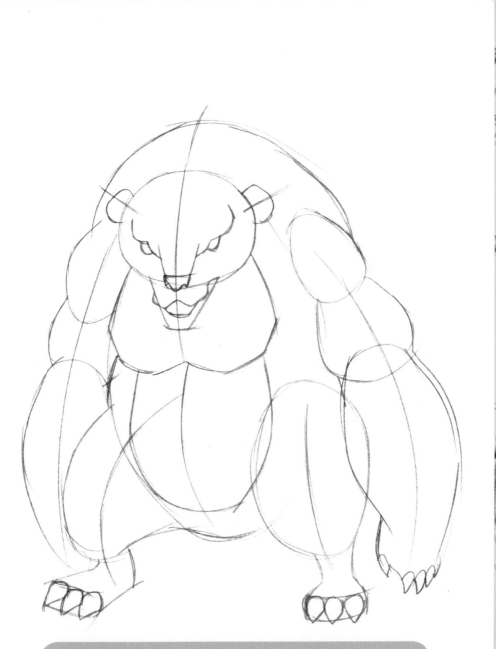

STAGE 3

Now draw a hunched back above the head, and large bulky arms hanging down to the ground. The forearms are extra-bulky to suggest power. End the paws in short, sharp claws.

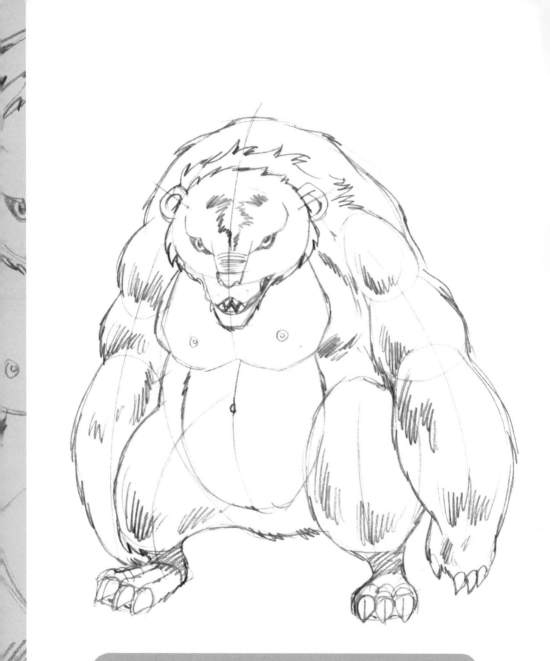

STAGE 4

Next, sketch in a shaggy outline and add some fur marks to the body and head. Draw some sharp teeth in the mouth space.

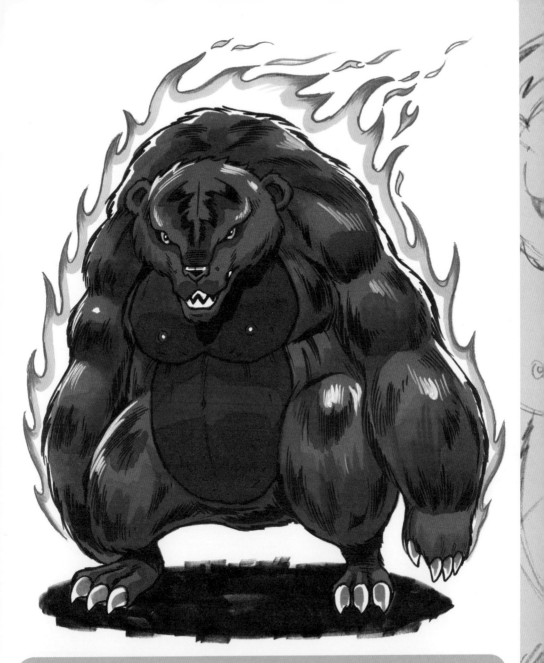

STAGE 5

Ink and colour the bear a vibrant flame-red, with darker maroon for shading and contrast around the muscles and stomach. Add black shadows under the chin, hind legs and on the ground to make the figure more dramatic and weighty. Finally, add small licks of blazing yellow and red flame surrounding the figure, to suggest movement.

Gecko-nator

That sweet-looking gecko would be a different kettle of...er, fish, in this monstrous, fight-hungry version.

STAGE 1

Draw a small circle for the head, with a long sweeping shape for the body and tail. Note how the end of the tails curls up like a question mark.

STAGE 2

Draw a shoulder line at mid-point through the head, and add large shoulder joints and arms. Add two legs coming out from the body shape, with three spread toes on each foot.

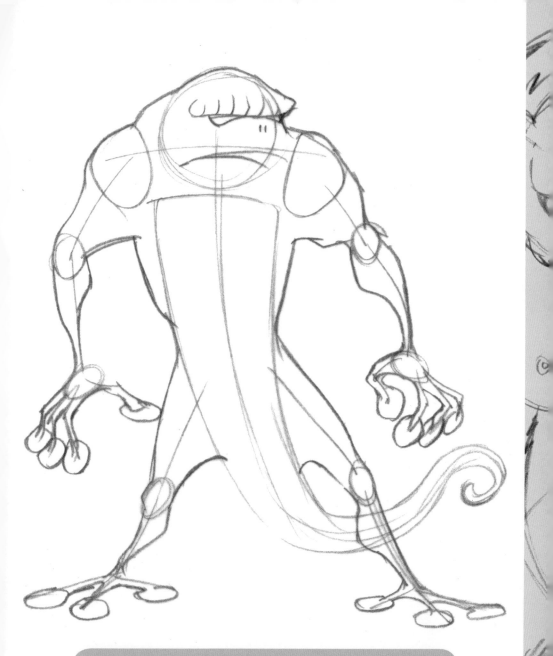

STAGE 3

Flesh out your figure with muscled upper arms and legs. Add sucker pads to the fingers and toes, and draw a heavy corrugated brow with narrow eyes, reptilian nostrils and a wide slit mouth.

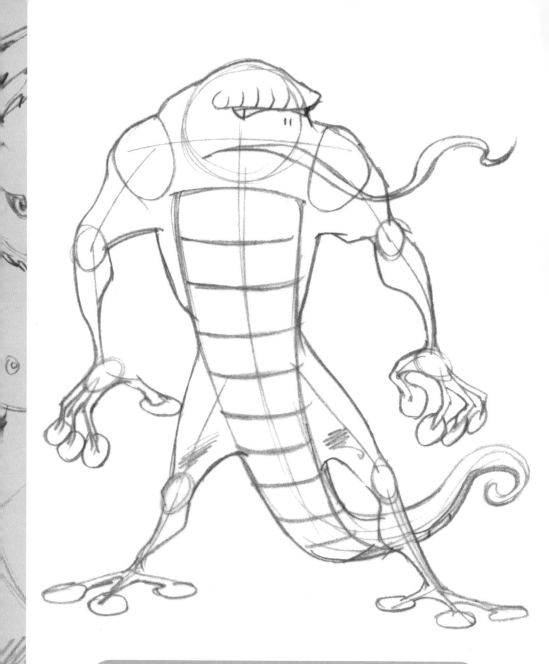

STAGE 4

Next, draw a snaking tongue whipping out of the mouth, and add rectangular armour plates to the chest and tail.

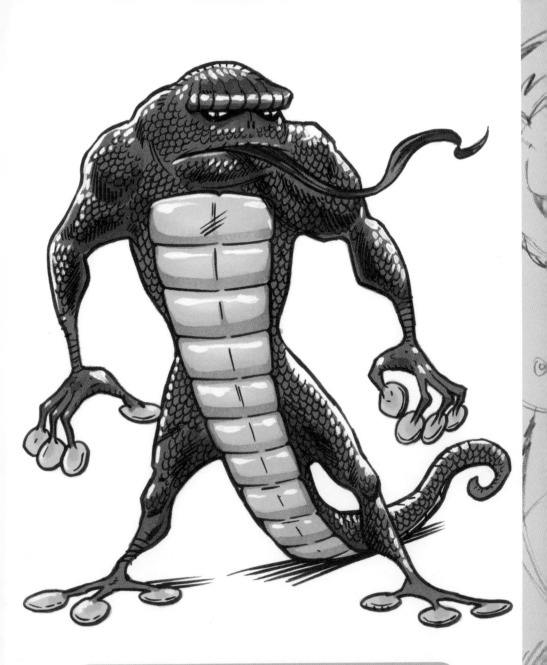

STAGE 5

Ink your drawing and colour in greens and purples. Use darker tones to define the body, and finish by adding lots of tiny scales in black, and small white highlights on the outer edges of the body.

Winged sloth

This slow-moving sloth has mutated bony wings and horns, turning it into a deadly hunter!

STAGE 1

Draw a conical oval shape a bit like an upturned strawberry, with an extended neck and head section with two thin horns and snarling mouth. Sketch out four jointed lines to indicate leg position.

STAGE 2

Fill out the body and legs, and add three long claws to each foot.

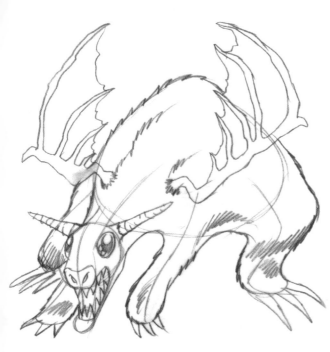

STAGE 3

Draw two bone-framed wings jutting from the shoulders, and add some furry shading to the outline.

STAGE 4

Ink and colour your drawing using grey and blue for the body, and brown and beige for the wings and horns. Add a splash of red to make the eyes and mouth stand out.

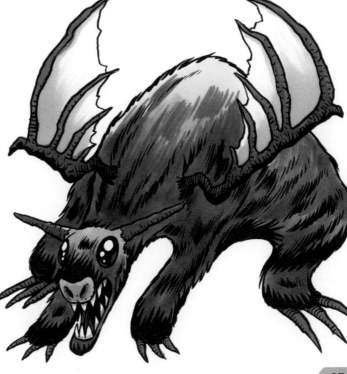

Sharkrawler

Sharks are scary enough in the water – what if they were mutated into armoured land crawlers?

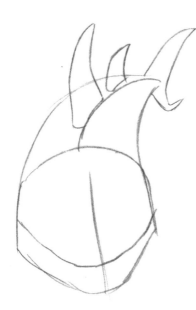

STAGE 1

Sketch out a basic shark outline with the tail curving off to the side

STAGE 2

Add three triple-sectioned legs on either side, with each one ending in a sharp hook.

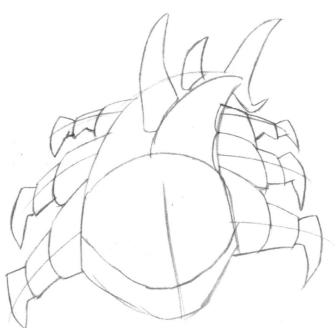

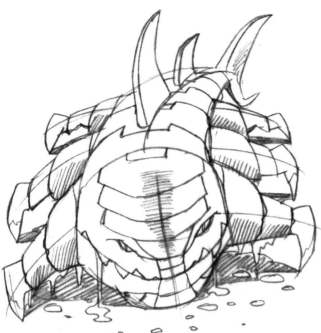

STAGE 3

Draw in a series of armour plates through the face, head and body. Add narrowed eyes and a wide mouth with irregular teeth. Indicate a strong shadow underneath and some random pebbles, to show the sharkrawler is on land.

STAGE 4

Ink and colour in metallic greys, mauve and pale blue, with a hint of yellow in the eyes and on the legs. Add a touch of maroon to the hook feet.

99

INSECTOID

Insects and other creepy-crawlies are probably the most scary-looking, terrifying creatures we see in the world around us. As human beings we appear to have an instinctive revulsion towards these small, crawling and flying creatures. This might be from a deep-rooted sense of self-preservation in the case of insects that bite and transmit diseases, or it might be that we just don't like the idea of small creatures happily going about their business under our very noses, but at a size which means we don't usually notice them. Small children are often warned of bed bugs when they go to sleep, and there are many scary tales of malevolent spiders which are intent on our destruction.

Of course, some insects are more scary than others. A pretty butterfly, for example, will cause delight rather than fear in the average person. Bees are usually seen as cute, whereas a wasp is best avoided. Whether it's a spider or a ladybird though, most insects do share certain characteristics, such as antennae, multiple-sectioned legs and separate head, thoracic and abdominal sections. To draw an insectoid monster you need to play with these features in interesting ways.

BZZRBT!

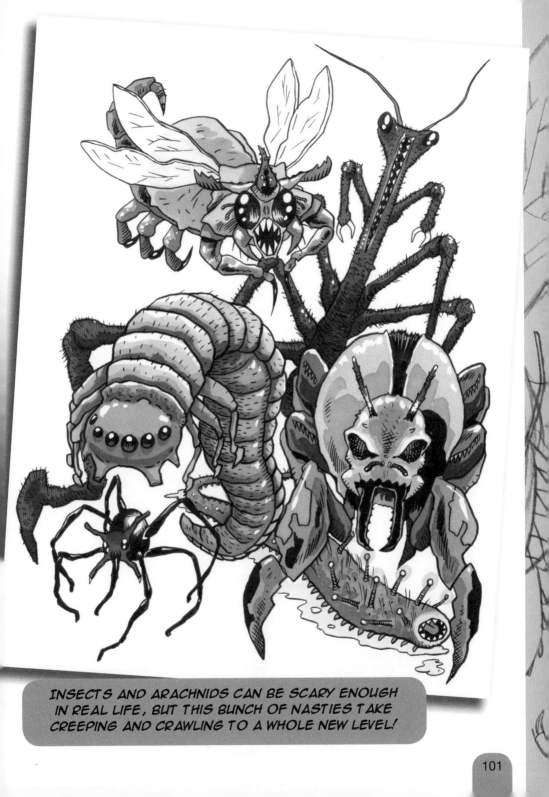

INSECTS AND ARACHNIDS CAN BE SCARY ENOUGH
IN REAL LIFE, BUT THIS BUNCH OF NASTIES TAKE
CREEPING AND CRAWLING TO A WHOLE NEW LEVEL!

INSECT FEATURES

Insect and arachnid heads have a number of common features which vary wildly across the huge range of species. You can use some of these characteristics to make your monster truly horrific.

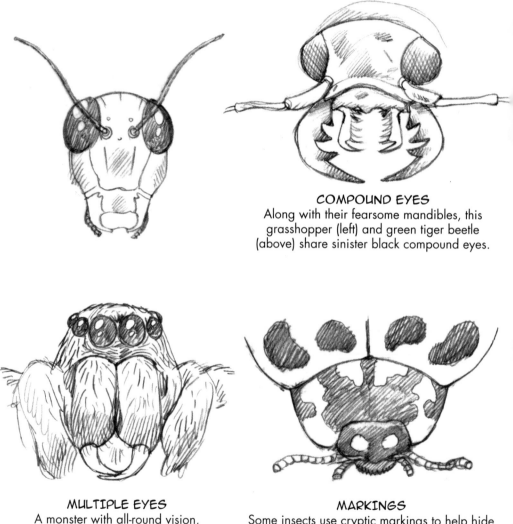

COMPOUND EYES
Along with their fearsome mandibles, this grasshopper (left) and green tiger beetle (above) share sinister black compound eyes.

MULTIPLE EYES
A monster with all-round vision, like this zebra jumping spider, is hard to sneak up on.

MARKINGS
Some insects use cryptic markings to help hide from predators. However, some have brightly coloured markings, like this ladybird, which warn their enemies that they are toxic.

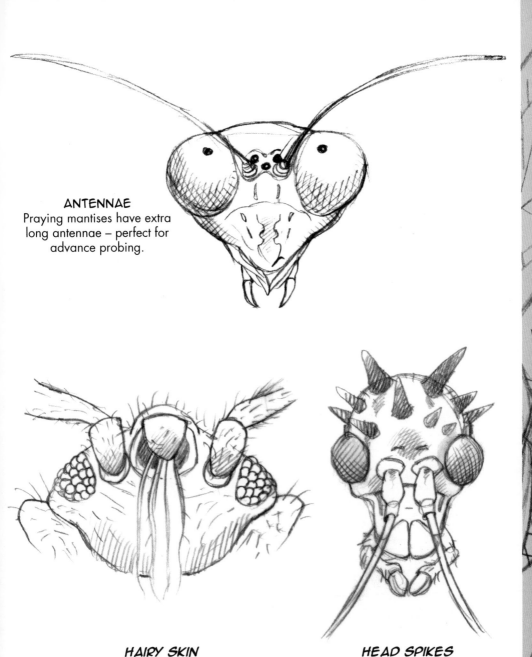

ANTENNAE
Praying mantises have extra long antennae – perfect for advance probing.

HAIRY SKIN
Like many insects, this bed bug's skin appears hairy.

HEAD SPIKES
This stick insect's prickly head helps to fend off enemies.

INSECTOID HEADS

Here are some ideas for insectoid monster heads, using some of the features shown on the previous pages.

Triple-jawed crunchworm

This worm has a three-tiered jaw which latches onto its prey and injects poisonous saliva.

STAGE 1
Start with a rough circle, bisect it with a horizontal curve and indicate two eyes. Draw a vertical trunk with a rounded triangular base.

STAGE 2
Draw in three sets of serrated mandibles and indicate a protruding brow.

STAGE 3

Add four smaller eyes and shade them in, leaving small white highlights. Draw two dangling hairy tentacles and some stretched saliva shapes in the open jaw.

STAGE 4

Ink and colour in reds and yellows, with a contrasting green in the eyes.

Troglerbug

A tiny, horned bug with a vertical mouth lined with razor-sharp teeth. Its small, spiky horns contain an anaesthetic venom so you can't feel it feeding on you!

STAGE 1

Draw three oval shapes in ascending size, with a central dividing line.

STAGE 2

Add two jointed legs on either side, with small mandibles in the centre. Indicate two side-mounted eyes on the middle shape.

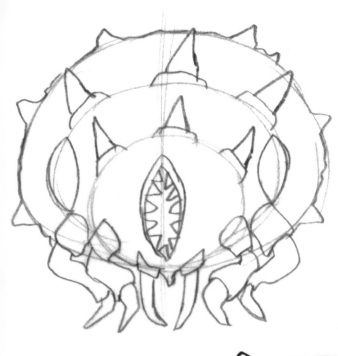

STAGE 3

Next, draw a vertical mouth with small, sharp teeth lining either side. Add a series of spiked horns at regular intervals around the edge of each shape.

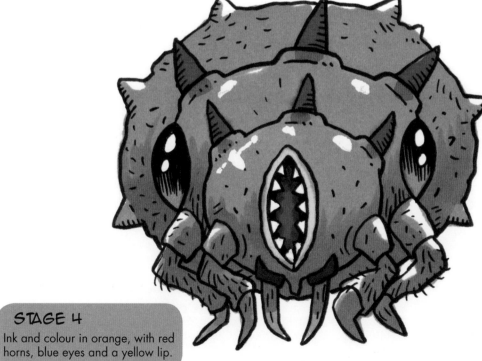

STAGE 4

Ink and colour in orange, with red horns, blue eyes and a yellow lip.

Cocoon-headed beetle

This beetle's cocoon-shaped head contains thousands
of microscopic burrowing organisms.

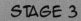

STAGE 3

Draw a leaf-like structure to the upper shape and add some thin feelers and five small eyes.

STAGE 4

Ink and colour in pale blue and greys with strong black shadows and hair texture.

King-crested snouter

The king-crested snouter sports a regal horned head. Its long snout and cheek tentacles can locate its prey in pitch darkness underground by sniffing and feeling its way along the ground.

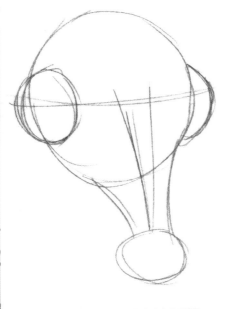

STAGE 1

Draw a circular head with a long, narrow snout ending in an oval mouth. Indicate side-mounted eyes.

STAGE 2

Add two thin tendrils on either cheek, and a fleshy rim around each eye. Draw a thin almond-shaped mouth with small teeth.

STAGE 3

Sketch a row of crown-style points around the top of the head. Draw a line of small horns along the snout and some concentric circular sections with a hairy texture.

STAGE 4

Ink and colour in aqua, with orange eyes and lips. Use black and white highlight spots for the eyes to make them look shiny and reflective.

Buzzdog

Combining insect parts with other types of creatures is a sure-fire way to make something very unsettling. This fly-eyed monster has a doberman-style head and crab legs in its mouth – and I don't mean to eat them!

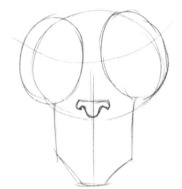

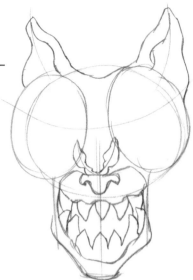

STAGE 1

Start with a tall, rectangular head shape, and add two large oval eye-shapes. Draw a small dog nose in the centre.

STAGE 2

Now add some tall pointed ears, and work on the muzzle with sharp canine teeth and a pair of crab feelers above it.

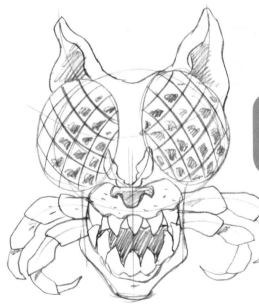

STAGE 3

Divide the eyes with diagonal lines and add two crab legs coming from either side of the mouth.

THE DOG EARS FORM
MONSTROUS EYELIDS.

CAREFUL
COLOURING
MAKES THE
EYES LOOK
REFLECTIVE.

MOTH-LIKE
ANTENNAE HELP
THE BEAST FIND
ITS PREY.

CRAB LEGS HELP
SCOOP PREY INTO THE
VICIOUS JAWS. NO
ESCAPE FROM THIS
MONSTER!

STAGE 4

Now ink and colour your drawing. The eyes are multi-faceted, so you see a repeat image in every facet. Colour the dog parts brown and the crab parts pink.

Snagle

This one is a cross between a stag beetle and a snail, with a triple eye thrown in for good measure.

STAGE 1

Draw a rough rectangle with slightly bulging sides, and indicate two lines for feeler positions in the top corners, and two curving lines for the mandibles below.

STAGE 2

Flesh out your shape with wavy lines, and end the feelers with round nodules. Draw some sharp-looking claw shapes on the mandibles and draw a curving line across to form the top of the mouth.

STAGE 3

Now draw large, wide eyes on the front and side of the head. I have made it a feminine-looking eye with curved lashes.

SENSITIVE FEELERS HELP THE SNAGLE
SENSE ITS PREY.

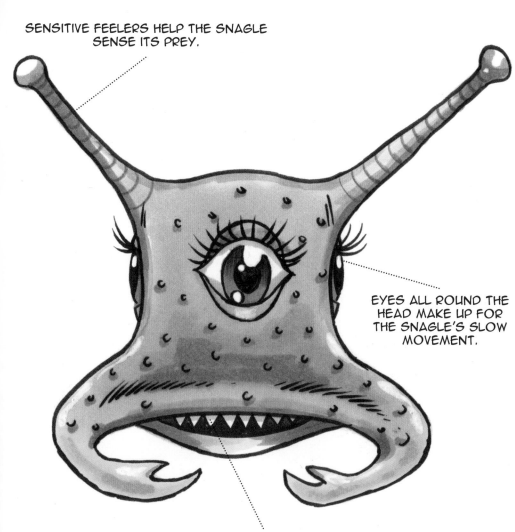

EYES ALL ROUND THE
HEAD MAKE UP FOR
THE SNAGLE'S SLOW
MOVEMENT.

THE CURVED EYELASHES CONTRAST
WITH THE SHARP TEETH FOR AN
UNSETTLING EFFECT.

STAGE 4

Ink and colour your head in a light blue. Add pimples across
the face and colour the iris of the eye orange/brown. On
the feelers, add some concentric lines with a blue pencil for
some extra detail. Shade with a slightly darker blue for a
more three-dimensional feel to your head.

115

Pig-nosed bush parasite

This ugly little chap can literally scare its victims into immobility – its multi-faceted eyes enable it to hypnotise its prey with a dazzling cascade of light.

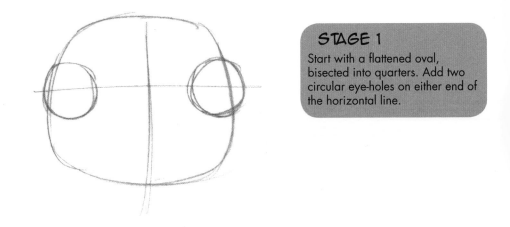

STAGE 1
Start with a flattened oval, bisected into quarters. Add two circular eye-holes on either end of the horizontal line.

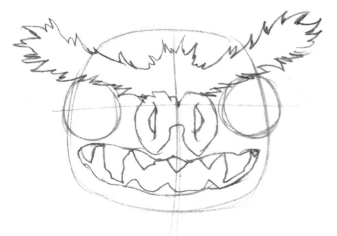

STAGE 2
Draw a symmetrical snout in the centre, with a wide bushy brow above and open mouth below.

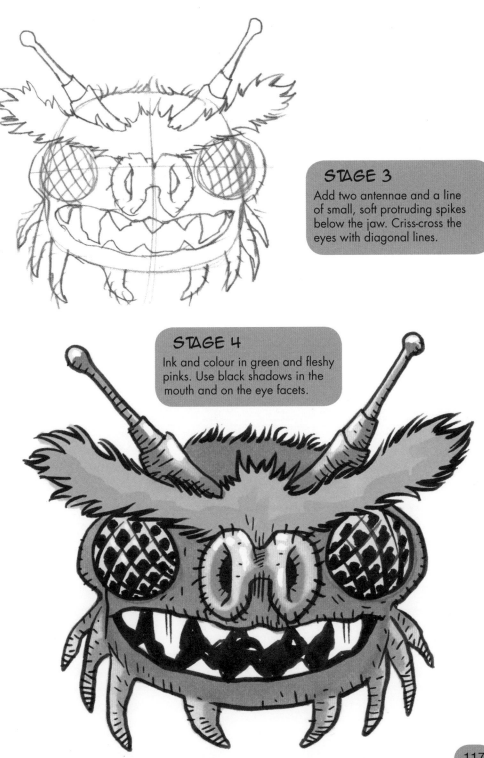

STAGE 3

Add two antennae and a line of small, soft protruding spikes below the jaw. Criss-cross the eyes with diagonal lines.

STAGE 4

Ink and colour in green and fleshy pinks. Use black shadows in the mouth and on the eye facets.

Horned oysterbug

The horned oysterbug attracts victims by giving off a delicious vanilla scent through its horns, then clamps on for a snack. Once attached, there's nothing you can do to remove it!

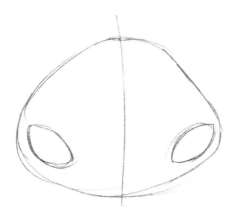

STAGE 1
Start with a flattened pear shape, and sketch two almond-shaped eyes.

STAGE 2
Draw curved diagonals on the eyes, and divide the head with a serrated line for the mouth. Add some indication of texture with small marks and bumps.

STAGE 3
Next, draw some spiky horns at random angles protruding from the top of the head.

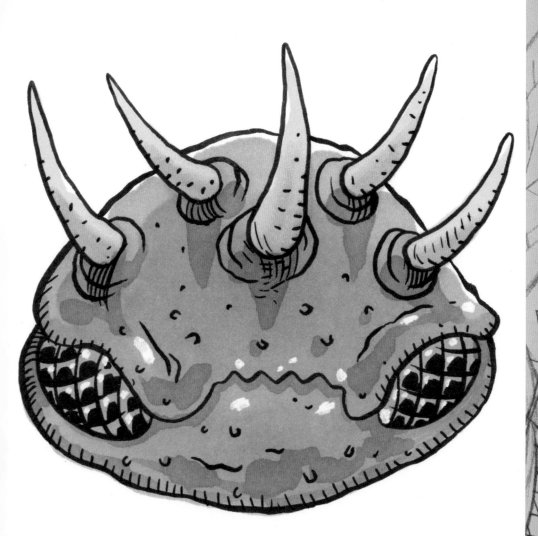

STAGE 4

Ink and colour in mauve shades with yellow horns and green eyes. Add small flecks of white paint on the eyes and head for added texture and depth.

EXAMPLE INSECTOID MONSTERS

Combining insectoid features on heads creates some deadly-looking monsters. Adding a body will turn it into a real terror – particularly if you combine it with another creepy-crawly in unexpected ways.

Staggerat

Stag beetles are pretty scary-looking already – just a few changes can make a real powerhouse scuttling menace!

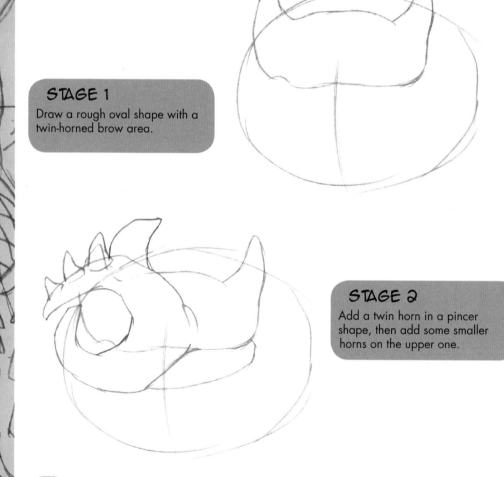

STAGE 1
Draw a rough oval shape with a twin-horned brow area.

STAGE 2
Add a twin horn in a pincer shape, then add some smaller horns on the upper one.

STAGE 3

Next, draw a mix of teeth and tentacles in the mouth, and a wrinkled, hooded eye.

STAGE 4

Develop the armoured body and add lots of separate plates, and draw six hairy sectioned legs.

STAGE 5

Ink and colour in dull greys and blue, with some black shadows to add weight and contrast.

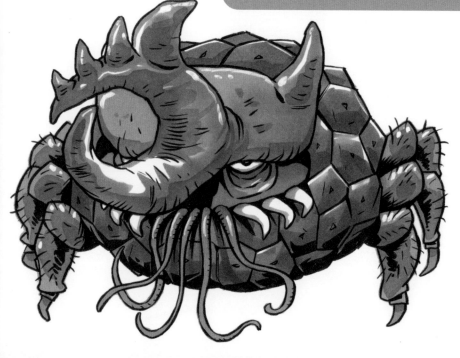

Sentry-pede

Insects – even enormous man-eating ones – do
not get bored, so they make excellent guards.

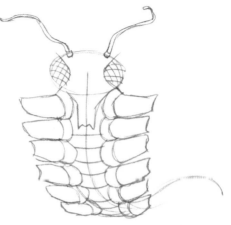

STAGE 1

Begin with an oval head-shape
with a drop jaw area, and sketch
in two long antennae and side-
mounted compound eyes. Draw
a wavy line trailing down and
away to the right for the position
of the body.

STAGE 2

Now draw a sectioned chest area with six leg
mountings on either side, running vertically down the
chest. Note the shape follows the curve of our guide
line at the bottom.

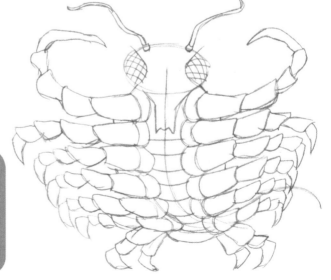

STAGE 3

Add jointed leg sections to the
mountings. The top two point up
and inwards, ending in sharp
spikes, while the rest point
downwards. Draw two standing
legs on either side at the bottom.

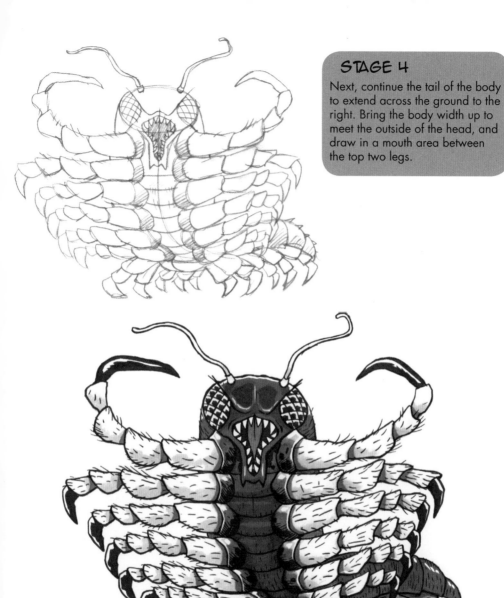

Next, continue the tail of the body to extend across the ground to the right. Bring the body width up to meet the outside of the head, and draw in a mouth area between the top two legs.

STAGE 5

Ink and colour in red, grey and black. Add lots of short hairs to the leg sections and colour in light grey, with dark grey mountings and black foot spikes. Shade the red on the lower under-body with mid grey to add depth.

Toxic slug

This nasty little pest emits a foul-smelling stink from its
many body vents!

STAGE 1

Start with a loose semi-circle, with a smaller half-ellipse at
the far left end.

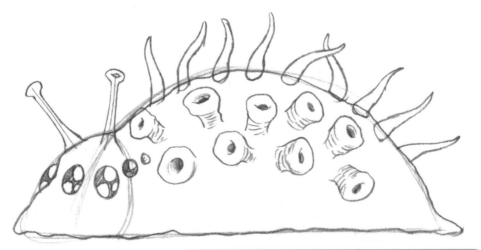

STAGE 2

Add a pair of antennae, a row of multiple eyes and some
soft spikes along the ridge of the back. Draw a group of
tubular vents on the side of the body.

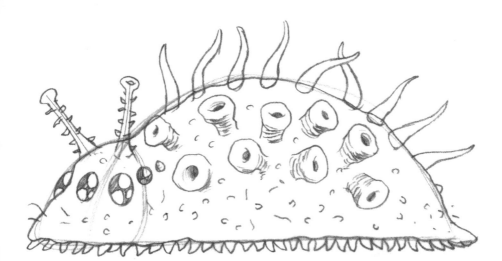

STAGE 3

Add a row of small tentacle-feet, and some small spikes on the antennae. Draw texture on the body, with pimples and assorted hairs.

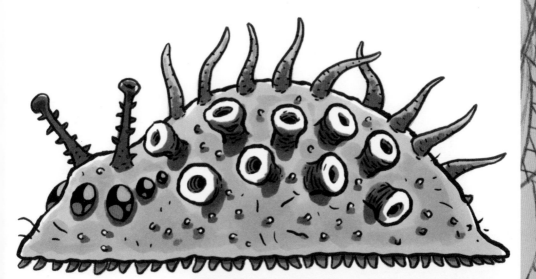

STAGE 4

Ink and colour in bright green, yellow and orange. Use a dull green for the antennae and shading under the vents.

Fangworm

Once this parasitic monster sinks its fangs into you,
there's no getting it off!

STAGE 1
Start with a circle for the head and draw a
long trailing line curling up at the end.

STAGE 2
Draw a long extended jaw with a ragged
edge and upturned bottom jaw.

STAGE 3
Fill out the body with corrugated irregular
sections leading to a small tail section.

STAGE 4
Draw two large fangs at the top and
bottom of the jaw, and a line of serrated
teeth between. Add a puddle of slime on
the ground under the body.

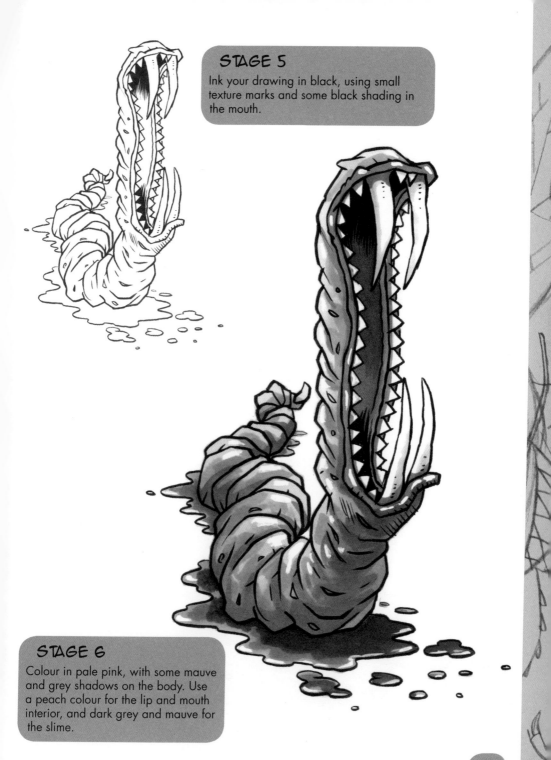

STAGE 5
Ink your drawing in black, using small texture marks and some black shading in the mouth.

STAGE 6
Colour in pale pink, with some mauve and grey shadows on the body. Use a peach colour for the lip and mouth interior, and dark grey and mauve for the slime.

Barbed spiderant

STAGE 1
Draw three egg shapes in
ascending size, then add eyes and
mandible jaws to the smallest.

STAGE 2
Connect the head to the
thorax section, and add
long, bony triple-jointed
legs on either side.

STAGE 3
Add two more legs on either side,
and finish the bottom of each leg
with a sharp hook.

STAGE 4
Draw barbs on each first leg joint, and on the lower
leg. Show a clutch of eggs being laid with long
strands of fluid.

THE GLOSSY CARAPACE MAKES THIS
MONSTER ESPECIALLY TOUGH.

VICIOUS HOOKED
BARBS HELP THE
SPIDERANT CLIMB.

WARNING
COLOURS
INDICATE THE
CLAWS ARE
POISONOUS.

GOOPY SLIME HELPS
PROTECT THE CLUTCH
OF EGGS.

STAGE 5

Ink and colour in your drawing with purple and black. Use
bright green in the eyes and on the barbed claws, and yellow
for the birthing fluid. Colour the eggs red with black shading.

Horned hoverbug

This noisy bug hovers overhead until it spots its prey – once located, it drops onto the unfortunate victim, injecting a lethal sting with its tail.

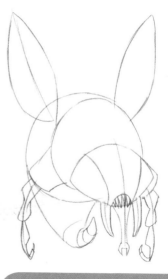

STAGE 1

Start with a lemon-shaped wedge and add two circular shapes behind in ascending size. Draw two leaf-shaped wings, and indicate eye areas on either side of the head, with a small mouth shape on the lower centre.

STAGE 2

Add a curling tail section ending in a sharp point. Draw appendages on either side of the thorax (middle section), and mandibles with a protruding proboscis on the face.

STAGE 3

Draw two antennae and add barbs to the mandibles and legs. Add large spikes of varying size on the body, and a central opening, lined with sharp teeth, on the abdomen and tail section. Finish the drawing with diagonal lines on the eyes and vein-like patterns on the wings.

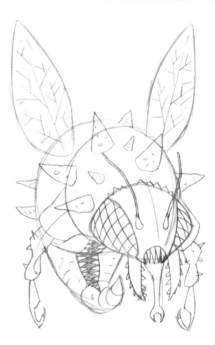

MOTION LINES HELP TO INDICATE THE FRANTIC BUZZING OF THE WINGS.

SHARP HIGHLIGHTS MAKE THE HORNS LOOK HARD AND GLOSSY.

SHARP MOUTHPARTS HELP TO ENSURE THE HOVERBUG'S PREY CAN NOT ESCAPE.

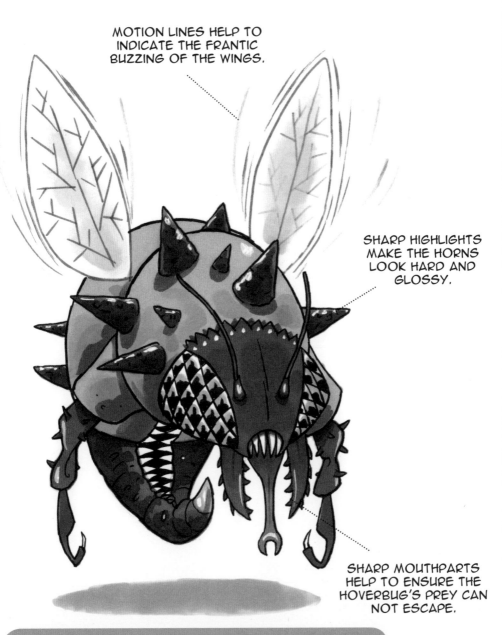

STAGE 4

Ink and colour in oranges, brown and brick red. Use some faint tones of pastel blue and grey on the wings, and use black shadows and pale mauve on the eyes. Use some faint motion lines on the wings, and try a drop shadow on the ground to indicate a hovering motion.

Star spider

A star spider weaves a fluorescent web and lures its victims with a dazzling electric display, before finishing them off with a powerful blast from its high-voltage proboscis!

STAGE 1
Draw a rough circle with a smaller square inside, with a diagonal line out from each corner of the square.

STAGE 2
Outline the head and add eyes, then draw a proboscis that ends in irregular filaments.

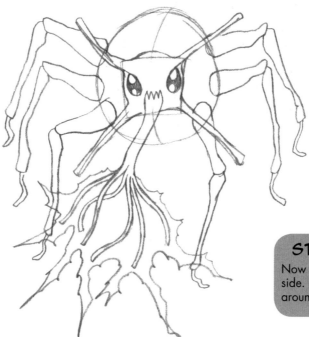

STAGE 3
Now add three legs on each side. Draw a burst of electricity around the filaments.

THIS CREATURE GIVES A
NASTY SHOCK!

STAGE 4

Ink and colour in dark grey, black and red. Use bright aqua
blue to outline the electrical charge and inside the filaments.
Add some pale blue around the edges of the electricity to
give an eerie glow.

KAIJU

The Japanese term *kaiju* translates as 'monster' in English, but it generally refers to a type of monster seen in Japanese monster movies and manga. Many kaiju have dinosaur-like characteristics, the most famous example being the mighty creature known as Godzilla.

Kaiju are normally giant-size and appear from the sea or from underground (sometimes as a result of nuclear testing by humans) before rampaging through Japanese towns and cities. Some kaiju are based on regular animals and insects, and there are also humanoid versions known as *kaijin*.

Since Godzilla's first screen appearance in 1954, kaiju have been popular movie and manga subjects, sometimes crossing over with similar Hollywood creations such as King Kong. Their personalities can be quite complicated – far from being evil monsters some can actually be quite sympathetic and misunderstood.

The earlier movies tend to be unintentionally humorous to modern audiences, with what were clearly actors in rubber suits stomping their way through miniature model cities. With modern CGI technology, however, kaiju have become much more realistic – and scarier!

Several American films have featured kaiju in recent years, such as *Cloverfield*, *Pacific Rim*, and of course more recent re-makes of the mighty *Godzilla*.

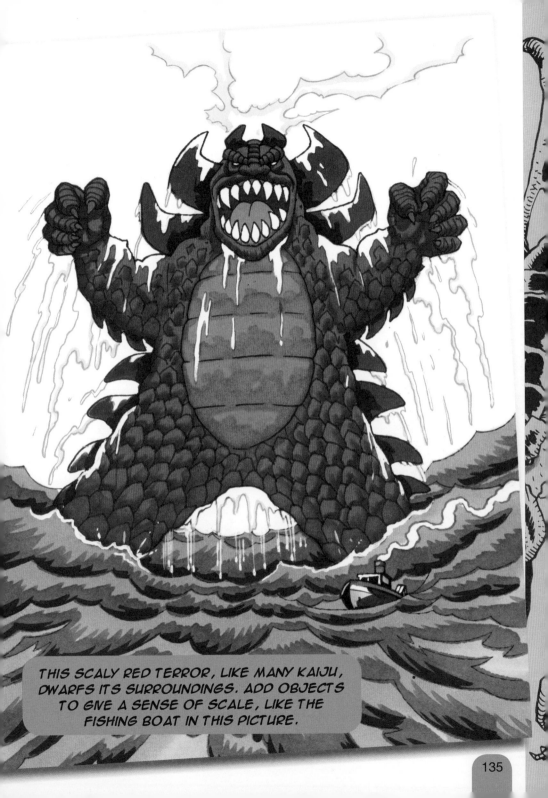

THIS SCALY RED TERROR, LIKE MANY KAIJU, DWARFS ITS SURROUNDINGS. ADD OBJECTS TO GIVE A SENSE OF SCALE, LIKE THE FISHING BOAT IN THIS PICTURE.

KAIJU FEATURES

Kaiju are fantasy monsters, but you can still use real-world reference of animals to help you draw them. Of course, you can also go back to the source and watch classic kaiju movies!

EYES
Kaiju monsters often have reptilian eyes, with a narrow vertical slit for a pupil, and scaly hooded eyelids.

TAIL
A curling armoured tail with sharp fins is a useful appendage for balancing as well as being a fearsome weapon.

SKIN TEXTURE
Kaiju skin can be armoured, furry, or, as shown here, covered in small scales.

WINGS
Kaiju may have bat-like wings with spiny bones and membranous sections between them.

EXAMPLE KAIJU

The unifying feature of kaiju is their great size. Beyond this, you are free to create almost anything. The following pages show just a hint of the variety.

Dinosaur kaiju

The classic kaiju is a lumbering, clumsy dinosaur – quite unlike the swift predators we now know those prehistoric reptiles to be.

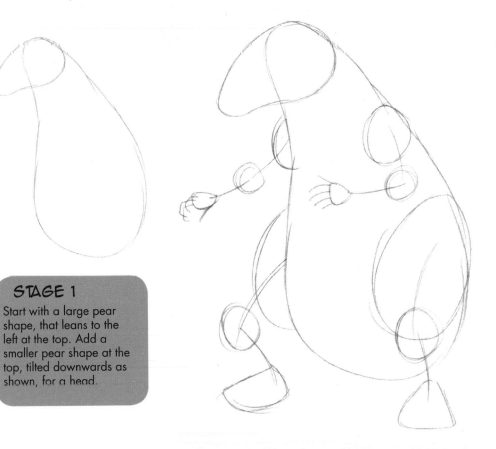

STAGE 1

Start with a large pear shape, that leans to the left at the top. Add a smaller pear shape at the top, tilted downwards as shown, for a head.

STAGE 2

Draw two short upper arms and two legs with large thigh areas to support the body and tail weight.

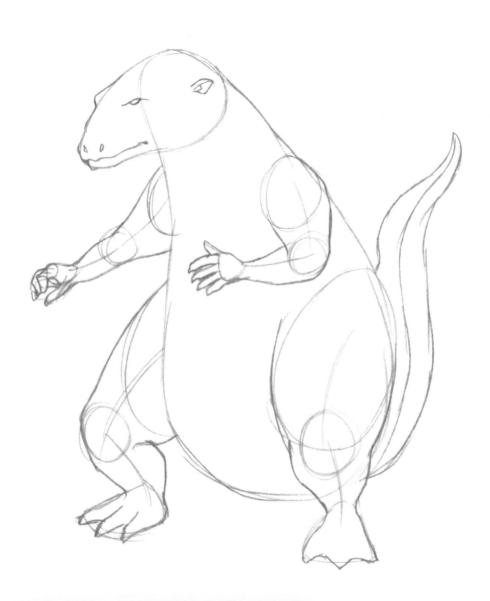

STAGE 3

Flesh out the arms and legs, then add a tail that rises
vertically from the rear. With those complete, add facial
features: small narrow eyes, a reptilian mouth and nostrils,
and a small ear.

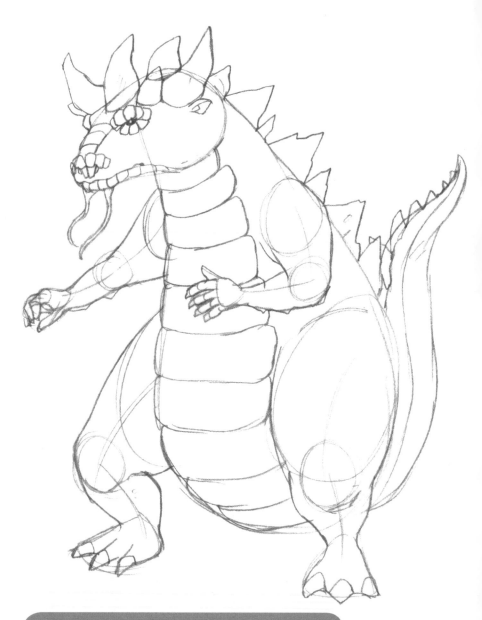

STAGE 4

Add spikes around the head and all the way down the back
and tail, then draw scaly surrounds to the eyes and face
along with two thin tendrils from the chin for a dragon-style
look. With those in place, draw a segmented chest area.

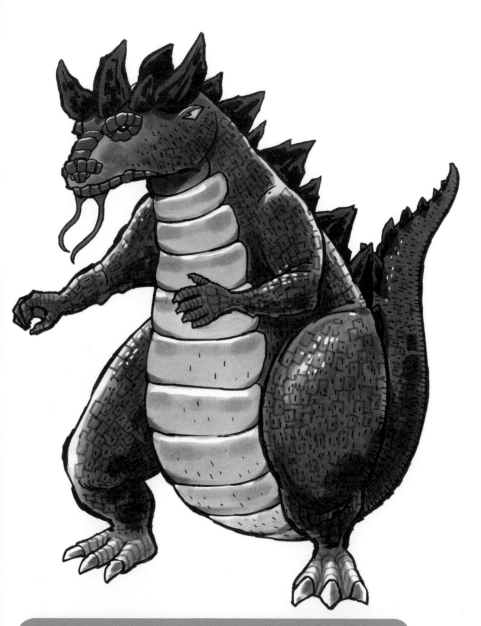

STAGE 5

Ink and colour your dinosaur-style kaiju in dull greys, with a hint of aqua blue in the highlights, and a dull red for the spikes and chin whiskers. Use a grey fibre-tip pen to add some random scales to the body. This gives texture to the body and makes it feel more realistic. Add some thin white highlights to the scales around the eyes and face, and you're done!

Tortoise kaiju

This spiky armoured nasty, based on a tortoise, has six thick legs to support his enormous weight, plus vicious scythe-like crests on his head and tail.

STAGE 1

Start with a rough semi-circle, bisect it with an upward-curving line ending in a small circle for the head.

STAGE 2

Detail the head with a serrated beak and heavy brow over a large circular eye. Remember to add in a highlight area. Follow the neck down, and draw a rocky frill along the edge of the shell.

STAGE 3

Add six stubby legs each resting on four sharp toes, a spiky, uneven carapace, a misshapen tail ending in a sharp hook-like weapon, and a menacing crest on the head.

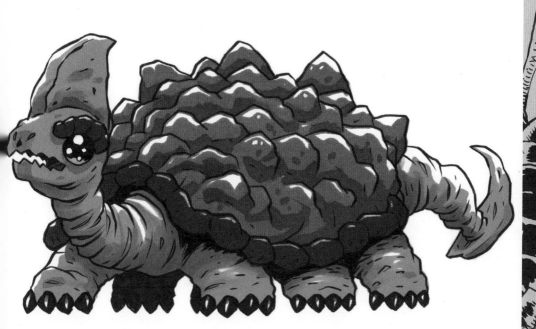

STAGE 4

Ink and colour your kaiju in fleshy, orange colours. Use darker shades to accentuate the spiky carapace, while leaving white highlights for extra three-dimensional effect. Add some contrasting colour to the eye to make it stand out.

Demon kaiju

A demon kaiju is one of the most deadly and ruthless foes a mecha – or another monster – might face. Its powerful clawed forearms can crush even the strongest armour, and its back-mounted vents emit a lethal poison gas.

STAGE 1

Start by drawing an oval head-shape, with a wide curving brow bone area, and bony protrusions on the cheeks and jaw. Add narrow eyes and a wide, thin mouth with sharp teeth showing.

STAGE 2

Draw a wireframe crouching figure, with the shoulders starting halfway up the head, and a shallow ribcage area in order to create perspective, as the figure is leaning forward. Have the back legs at a sharp angle for a low crouching stance.

STAGE 3

Flesh out the front legs, ending each in a two-toed foot. Draw a sectioned torso ending in a snaking tail.

STAGE 4

Develop the rear legs, then add some jagged vents protruding from the monster's back and elbows.

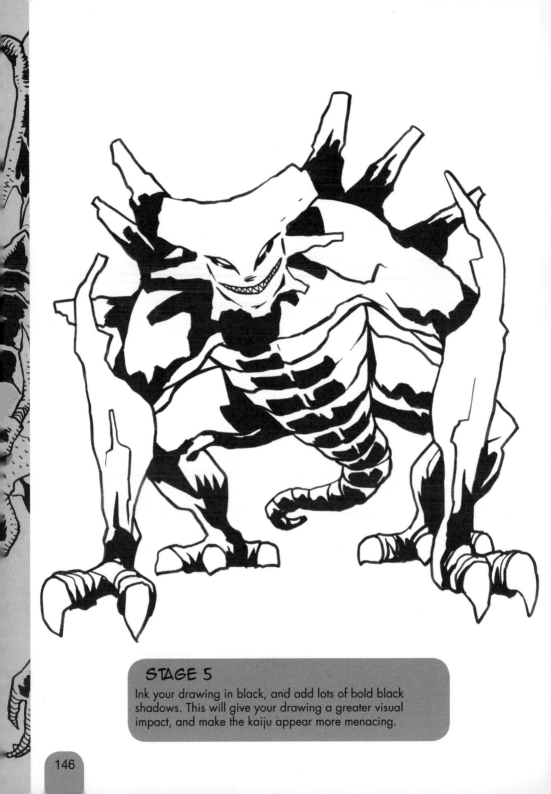

STAGE 5

Ink your drawing in black, and add lots of bold black shadows. This will give your drawing a greater visual impact, and make the kaiju appear more menacing.

STAGE 6

Colour your character in strong blue with contrasting creamy-white arms and legs. Use a dark grey on the claws, and add some wispy gas coming from the vents on the kaiju's back.

SIZE AND SCALE

When kaiju monsters are stomping their way through the city, you will find the desperate population relying on a bit of military intervention to fend them off. Adding some realistic military vehicles can help give your kaiju drawing a sense of scale, to show just how big they really are.

Here's a few suggestions you might consider using. Always get reference before drawing your military hardware – it makes a huge difference to the realism of your picture!

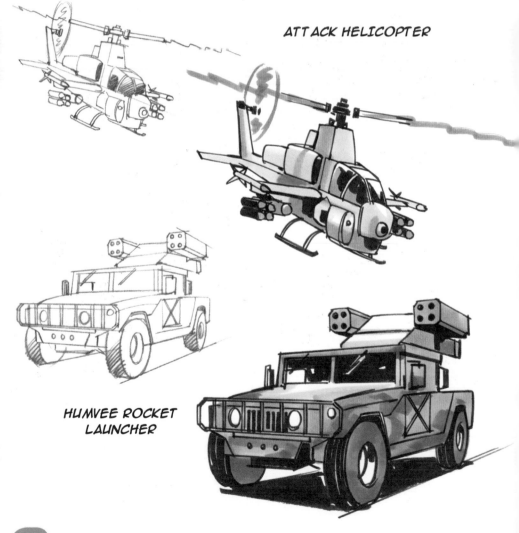

ATTACK HELICOPTER

HUMVEE ROCKET
LAUNCHER

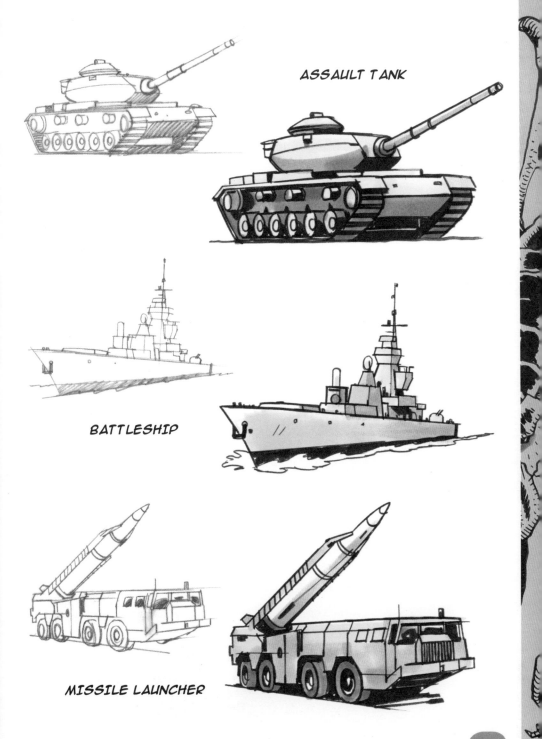

ASSAULT TANK

BATTLESHIP

MISSILE LAUNCHER

Simian kaiju

A simian kaiju is a giant ape monster that can use a city as its own personal gymnasium, swinging from building to building and smashing everything in its way. It can emit a savage, blood-curdling cry to terrify opponents.

STAGE 1

Start with a wireframe figure with one arm raised and one down to the ground. Draw a high shoulder line and widely spread legs.

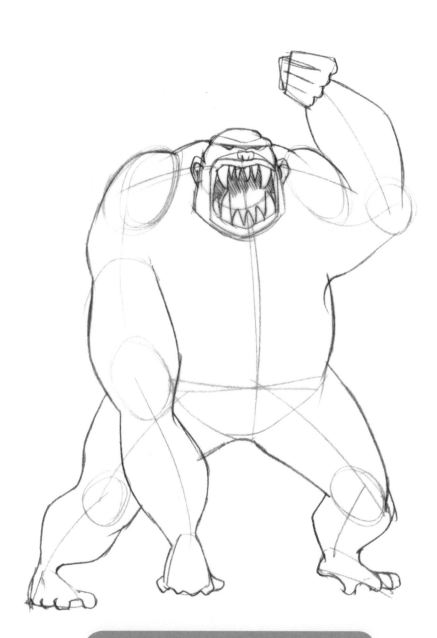

STAGE 2

Draw a gorilla-style head with large snarling mouth and flesh out the body with an extra-wide torso and large, bulkily-muscled arms and legs.

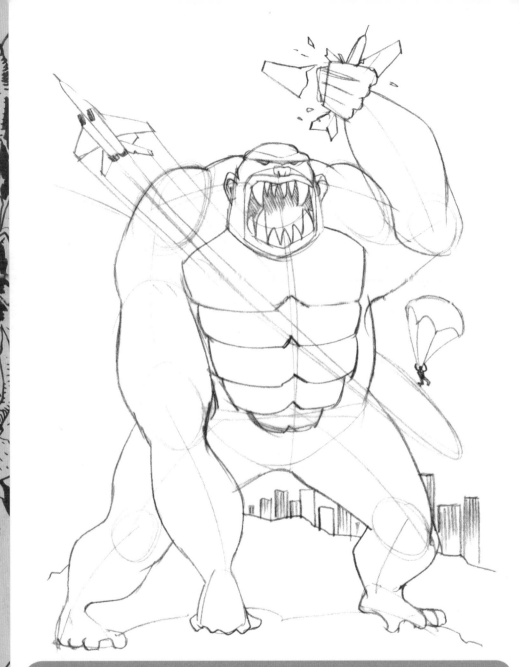

STAGE 3

Add some details to give a sense of scale to your figure. Draw one jet fighter soaring around the kaiju and another being crushed in the right fist. Add an ejected pilot figure parachuting to safety and a rough ground line with an indication of city buildings in the distance.

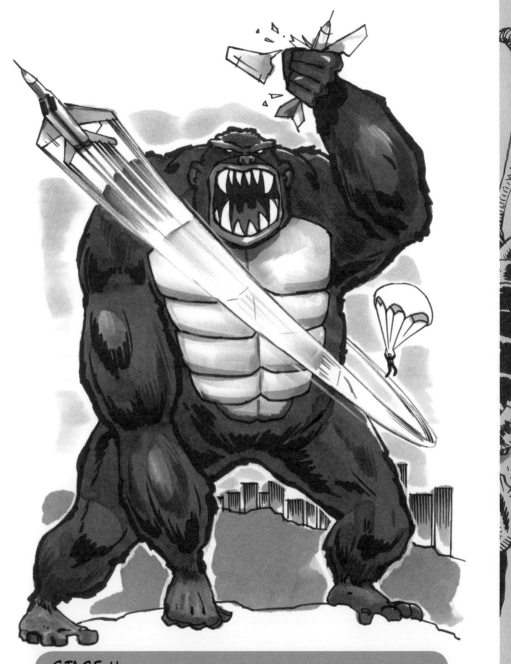

STAGE 4

Use a coarse, jagged line round your figure to suggest a furry texture, then colour in the kaiju a dull, dark brown with a contrasting beige stomach and chest area. Use greys and pale blue to add colour to the background setting.

Crustacean kaiju

This gnarly-shelled giant crustacean normally stays firmly at home on the bottom of the ocean, but on its occasional forays onto dry land its thick armoured shell and mighty claws can shrug off everything its enemies can throw at it!

STAGE 1

Start by drawing an egg-shaped oval, with a smaller oval at the lower left. Sketch in an open mouth with an irregular upper lip. Add a series of small horns on top of the head.

STAGE 2

Now add a crusty upper shell with a row of spikes across the top. Draw in some misshapen teeth, brow and eyes. Draw two long antennae protruding from the brow.

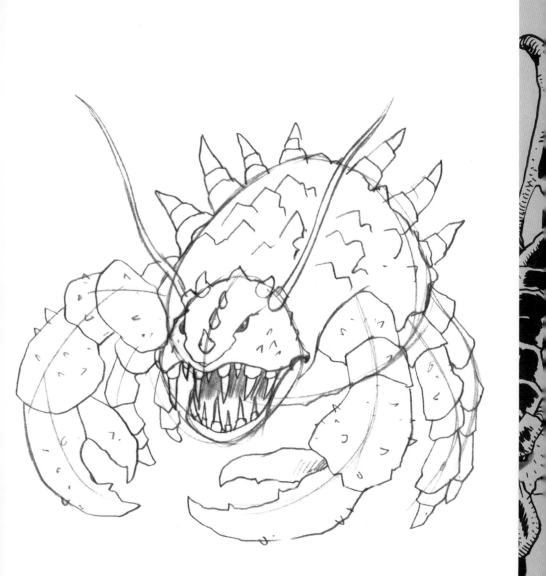

STAGE 3

Now add some jointed legs ending in large front crab-claws. Indicate some small lumps and spikes across the shell and claws.

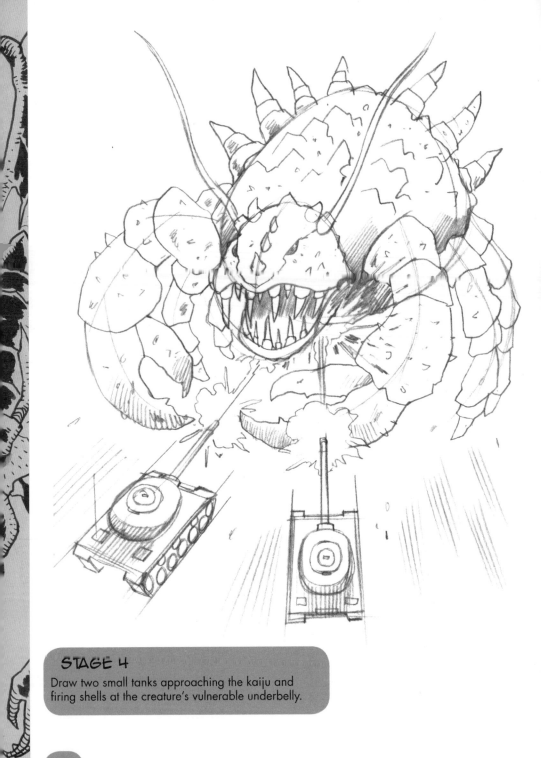

STAGE 4

Draw two small tanks approaching the kaiju and firing shells at the creature's vulnerable underbelly.

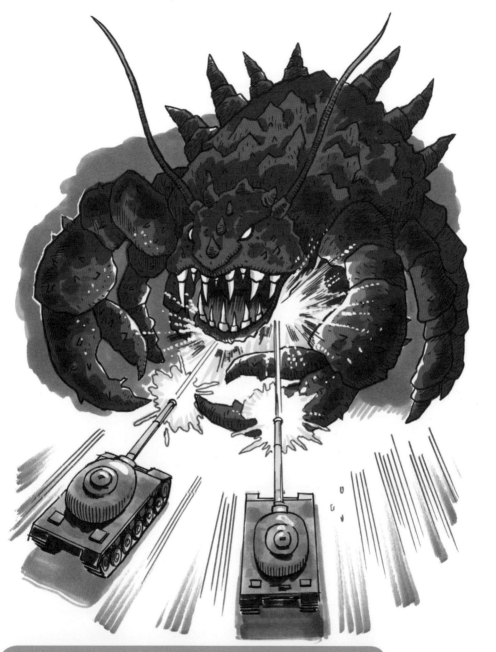

STAGE 5

Ink and colour your kaiju in red, with maroon shadows. Shade the body and claws from the outer edge – this gives a glow to the shells striking the body. Colour the tanks in yellow, beige and grey, then use a mid-grey to colour a rough background area with some shadow behind the tanks.

KAIJU POWERS

As well as the ability to swim and fly (not to mention the power to stomp on the odd city skyscraper!), kaiju sometimes have extra powers of destruction, such as the heat-vision or ice-breath shown here.

When drawing these powers it looks good if you outline the power with a coloured fibre-tip pen, as in these two examples.

ICE BREATH

KEEP THE CENTRAL AREA PURE WHITE.

AREAS SPILLING AWAY FROM THE MAIN BLAST SUGGEST RAW POWER.

HEAT VISION

EYE BEAMS LOOK
GOOD IF THE EYE IS
STILL VISIBLE.

USE COLOUR TO
SUGGEST THE TYPE
OF POWER.

Winged kaiju

This winged kaiju has the added fear factor of flaming breath, just like the mighty dragons of legend. Perhaps those ancient dragons were actually winged kaiju?

STAGE 1

Draw a wireframe figure with a small circular head and large triple-jointed hind legs. Use two lines dropping down from the head to indicate the position of its beak.

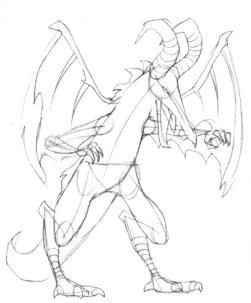

STAGE 2

Flesh out your figure and add forearms, horns and wings. Next, draw a balancing tail, continuing the angle of the body down to the ground behind. Add details like a jagged mane, bird-like feet and tongue.

STAGE 3

Draw some lines to add texture to the body, leaving the stomach area blank. Make sure the lines follow the contours of the body. Sketch in a flaming fireball blasting from the mouth, like a fire-breathing dragon.

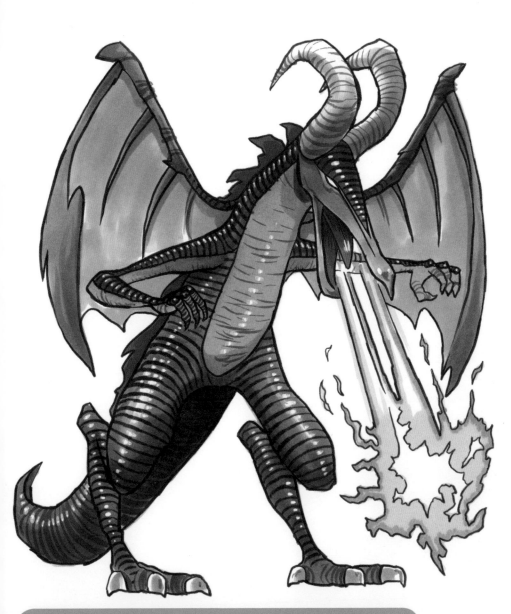

STAGE 4

Ink and colour your winged kaiju in green and grey, with a brick-red mouth and mane. Use yellow and orange on the fireball, and add a line of small white highlights to the body to give a shiny, reptilian finish. Note the dark shadow at the base of the tail where it meets the body. This shadow pushes it behind the legs visually.

Subsea kaiju

Subsea kaiju generally stay where they feel most powerful, down in the watery depths. This great beast's webbed hands and feet give it a fast turn of speed, and its huge head can make short work of anything foolish enough to come into range, like an unsuspecting submarine.

STAGE 1

First, draw a snake-like 'S' shape getting smaller as you reach the tail.

STAGE 2

Add some details to the shape, with a long thin mouth, twin horns and fins along the back and under the chin, and a bony eyebrow ridge.

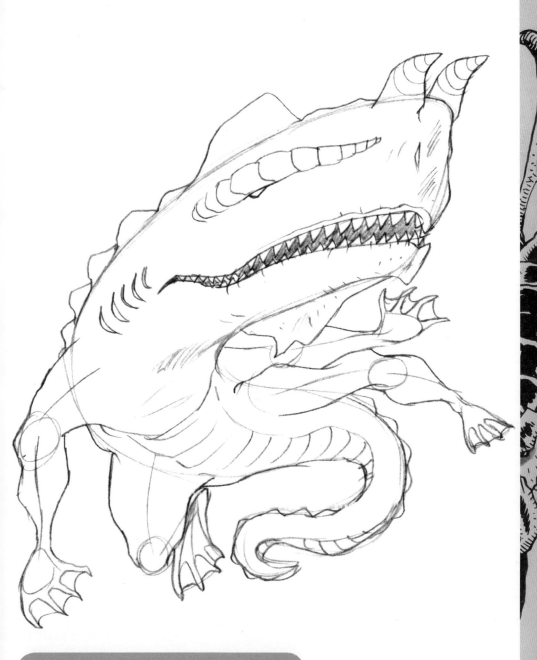

STAGE 3

Draw four limbs with webbed hands and feet, and a segmented underbelly. Continue the fins along the back all the way to the tip of the tail.

STAGE 4

To place it in an underwater setting, draw an irregular 'halo' around the kaiju, curling off into the distance. Add some tiny streams of bubbles rising vertically towards the surface, and give a sense of scale by adding a submarine passing overhead.

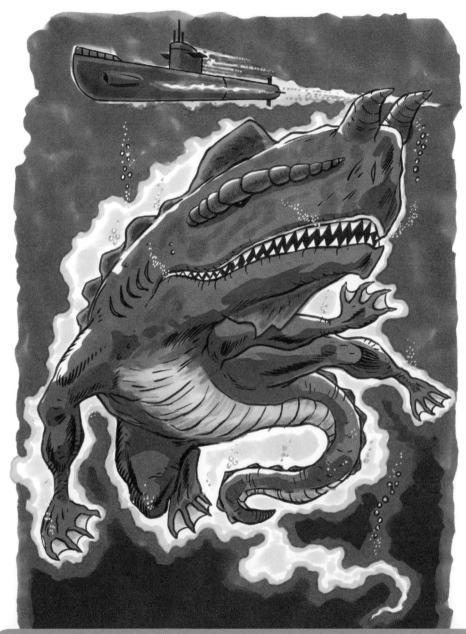

STAGE 5

Use black ink to line your kaiju and the submarine, and a blue fibre-tip to outline the halo. Colour the water in deep blue, and the kaiju in grey-green and orange. Use pale blue on the halo, leaving areas of white as shown. Make the submarine a dark grey and leave a trail behind it to suggest movement.

Aerial kaiju

Even taking to the skies will not save you from kaiju.
Some are tall enough to bat aircraft out of the air, and
some terrifying behemoths, like this winged monster,
can simply chase you up there!

STAGE 1

Start with a leaf shape
and bisect it, then add
an X-shaped area for the
position of horns and
mandibles.

STAGE 2

Draw in a long jaw with a jagged mouth, and extend the
horns upwards. Add two small eyes and layered head.
Sketch a high body shape with legs folded at the knee, and
a long vertical foot with claws. The left leg will be partially
obscured so you will just see part of the foot behind the jaw.

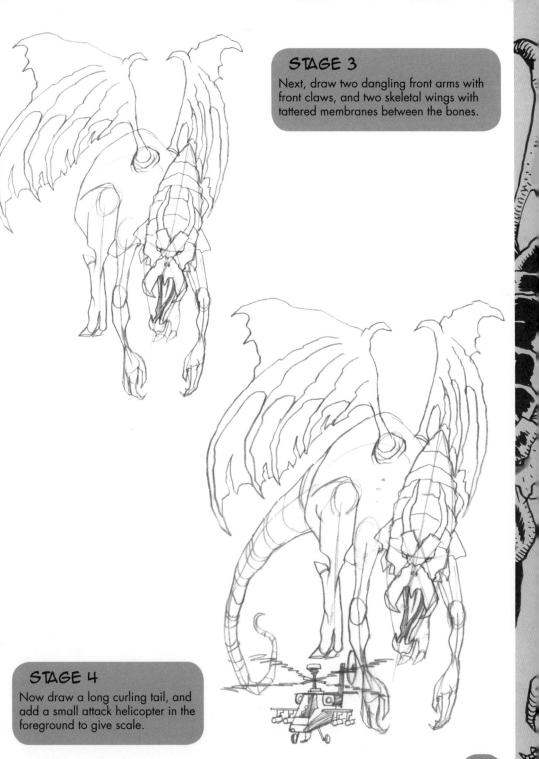

STAGE 3

Next, draw two dangling front arms with front claws, and two skeletal wings with tattered membranes between the bones.

STAGE 4

Now draw a long curling tail, and add a small attack helicopter in the foreground to give scale.

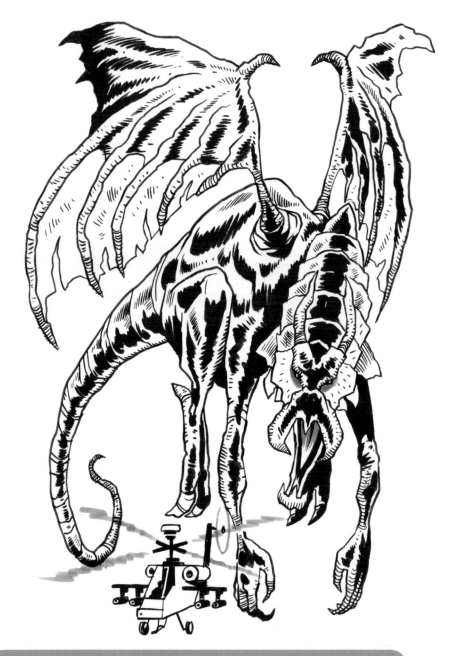

STAGE 5

Ink your drawing in black, with lots of solid shading areas to give your figure impact and indicate muscle and shadow. Use a mid grey brush pen to sketch in the moving rotor blades and shade around the eyes and in the mouth.

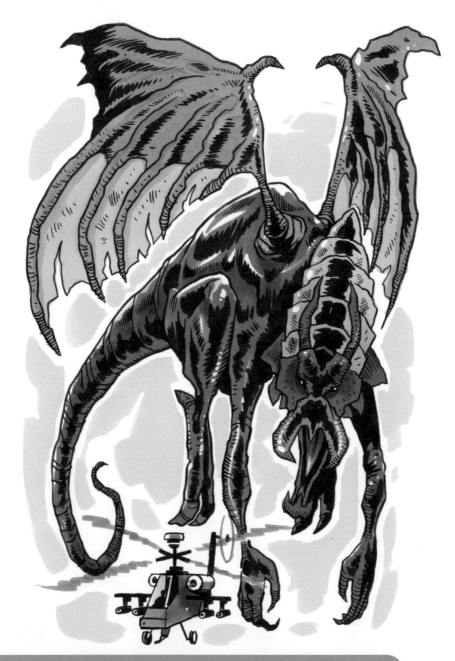

STAGE 6

Colour in mauve, lilac and grey, with a splash of sky blue on the background. The membranes on the wings are almost transparent, so make them lighter than the top part of the wings. Add a touch of peach in the mouth for contrast.

CHIBI MONSTERS

The word *chibi* is a Japanese word which translates as 'small' or 'short'. In slang it is sometimes used to describe short or small people in a rude or mocking way, but in manga the term has been adopted as a visual style to show cute little characters. It is often used to insert humour or cuteness into stories, sometimes when a character is having an 'internal dialogue' moment or expressing an extreme emotion.

The chibi style came to prominence for Western manga readers in a popular manga by Naoko Takeuchi, called *Sailor Moon*, a series in the 'magical girl' sub-genre. The look has also come to be associated with the style known as 'super-deformed', due to the extremely large head size in relation to the body.

The incredibly popular *Pokémon* franchise took the chibi characteristics and applied them to a host of pocket-sized monsters. What made the pokémon different from traditional monsters was that they were all exceedingly cute...

I'M FAR TOO TOUGH FOR THIS LOOK!

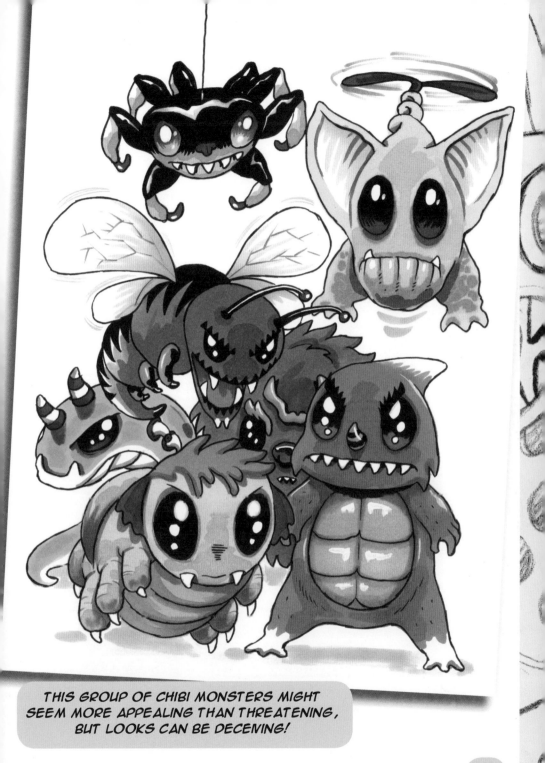

THIS GROUP OF CHIBI MONSTERS MIGHT
SEEM MORE APPEALING THAN THREATENING,
BUT LOOKS CAN BE DECEIVING!

CHIBI PROPORTIONS

The chibi style has some common characteristics.
Apply these to your monster to make sure you get the
distinctive look right.

THE HEAD IS LARGE
IN RELATION TO
THE BODY.

THE EYES ARE LARGE AND
OFTEN JUST PUPILS, WITH
NO IRIS OR WHITE AREA.

ANY HORNS OR SPIKES
ARE ROUNDED AND NOT
DANGEROUS-LOOKING.

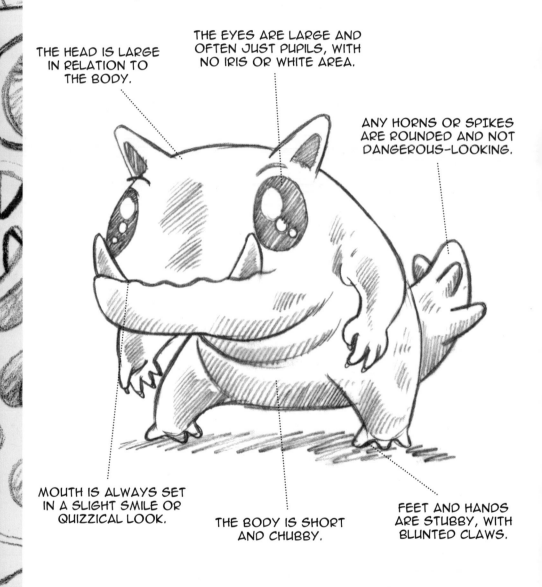

MOUTH IS ALWAYS SET
IN A SLIGHT SMILE OR
QUIZZICAL LOOK.

THE BODY IS SHORT
AND CHUBBY.

FEET AND HANDS
ARE STUBBY, WITH
BLUNTED CLAWS.

CHIBI MONSTER DETAILS

Chibi monster eyes are usually less threatening and scary-looking than other monster eyes. Similarly, chibi monster mouths rarely have a full set of teeth. Instead they have one or two short fangs sticking up or down from the sides of the mouth – more likely to give you a nasty suck than a bite!

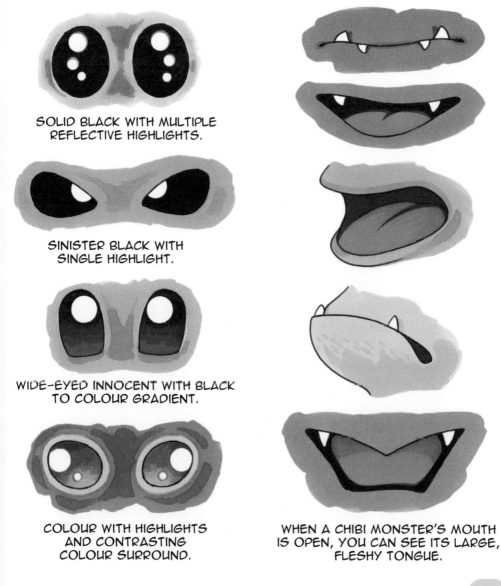

SOLID BLACK WITH MULTIPLE
REFLECTIVE HIGHLIGHTS.

SINISTER BLACK WITH
SINGLE HIGHLIGHT.

WIDE-EYED INNOCENT WITH BLACK
TO COLOUR GRADIENT.

COLOUR WITH HIGHLIGHTS
AND CONTRASTING
COLOUR SURROUND.

WHEN A CHIBI MONSTER'S MOUTH
IS OPEN, YOU CAN SEE ITS LARGE,
FLESHY TONGUE.

CHIBI MONSTER APPENDAGES

Chibi monsters can sport a dazzling array of appendages, the more colourful the better. Here are some examples!

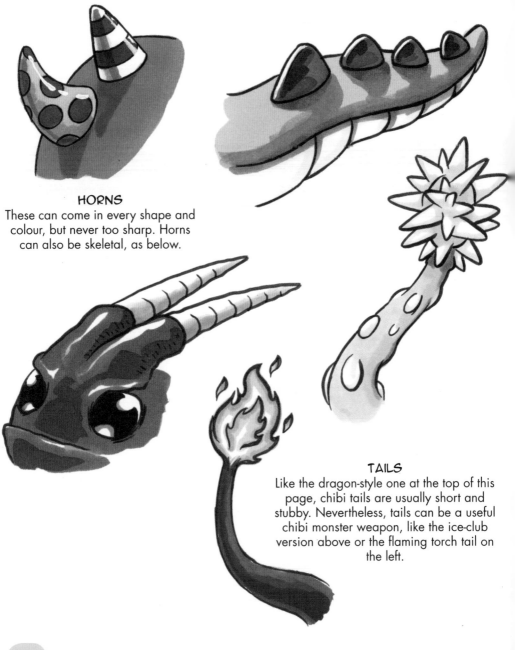

HORNS

These can come in every shape and colour, but never too sharp. Horns can also be skeletal, as below.

TAILS

Like the dragon-style one at the top of this page, chibi tails are usually short and stubby. Nevertheless, tails can be a useful chibi monster weapon, like the ice-club version above or the flaming torch tail on the left.

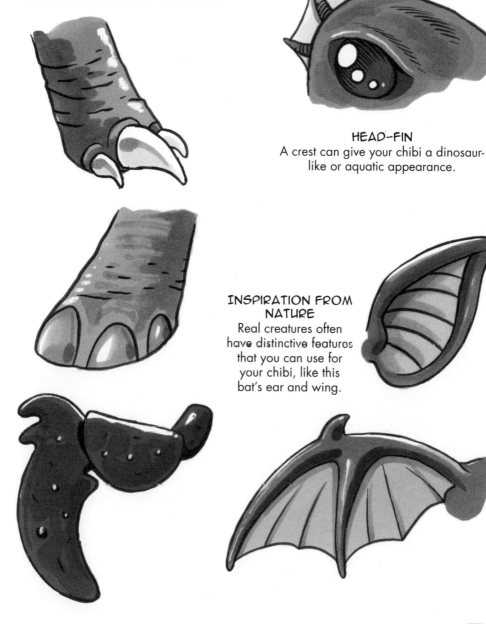

FEET
Chibi monsters can use almost any type of leg. When short and rounded-off, monstrous toes and claws can look cute. Even the crab-inspired jointed leg at the bottom looks safe when it's so short!

HEAD-FIN
A crest can give your chibi a dinosaur-like or aquatic appearance.

INSPIRATION FROM NATURE
Real creatures often have distinctive features that you can use for your chibi, like this bat's ear and wing.

Sparkle-tailed hog

This little beast has a thousand-watt charge coursing through its club tail. One swipe from that and it's goodnight!

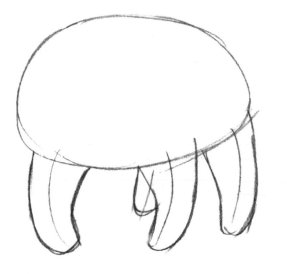

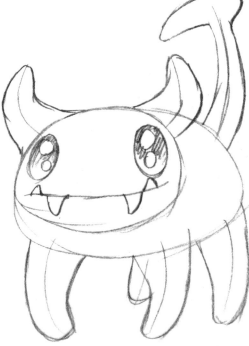

STAGE 1
Start by drawing a rough egg shape with four sturdy legs.

STAGE 2
Add two eyes and a thin mouth line, with two upturned teeth and two down-turned. Draw a horn on either side of the head and a tail ending in a rounded spike.

STAGE 3

Add a horn in the centre of the head and a soft, shaggy fleece on the body. Sketch some sparks coming from the tail and add three stubby toes to each foot.

STAGE 4

Ink and colour in golden yellow, purple and grey. Use a pale blue to outline the sparks and a bright green in the eyes.

Blue-billed squawker

You would not want one of these in a birdcage in your Granny's parlour – its tail can knock through a three-inch brick wall, while its piercing cry can make your blood curdle!

STAGE 1
Draw a jelly-bean shaped body with two standing legs.

STAGE 2
Add eyes and a large, open beak, then draw a short wing on either side of the body.

STAGE 3
Draw a tail with fins, and add a tall spikey clump of hair on the top of the head.

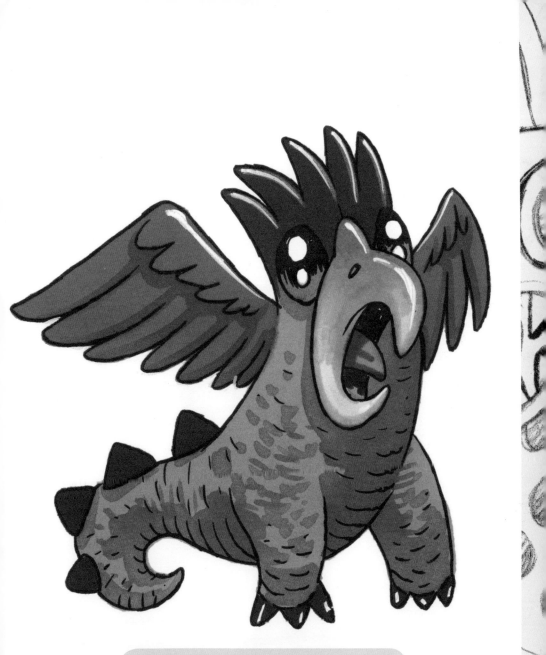

STAGE 4

Ink and colour the body in mid-brown, and use red and blue for the beak. Use a maroon red for the hair, toes and fins. Add a thin white highlight on the wings, hair and beak for a rounded look.

Spiny tortle

This feisty spiky-shelled little beast waddles across the ground quite slowly, but when in range its clubbed tail swings round with a crippling blow – best to walk the other way if you see one coming.

STAGE 1

Draw two irregular circles for the head and body, and add short, stout legs. Hide the rear left leg behind the body.

STAGE 2

Add a plated back, a bit like a pineapple, and draw two large eyes and a large open mouth with gritted teeth.

STAGE 3

Now add a small, rounded spike to each plate, and draw a short protruding spike with a mace-like end.

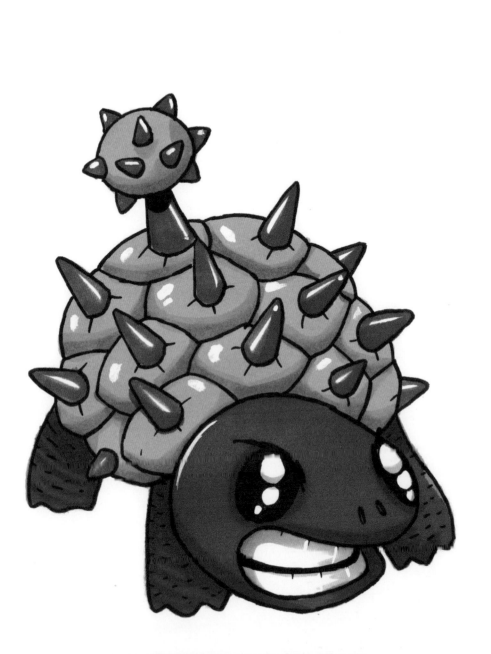

STAGE 4

Ink and colour in red and golden yellow, and use a hint of mauve for a shadow on the teeth under the top lip.

Pink punker

At first glance you might think the punker is quite cute. Don't be fooled! Its ferocious nature makes it master of its own territory, fiercely guarding its hunting ground with deadly skill and accuracy.

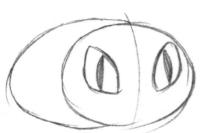

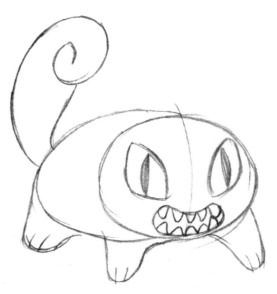

STAGE 1
Draw two ovals, one in front of the other, and draw two feline eyes with vertical slitted pupils. Bisect the head on a curve to help you position the eyes correctly.

STAGE 2
Next, draw a fat, curling tail and four short paws. Add an open mouth with gently rounded teeth.

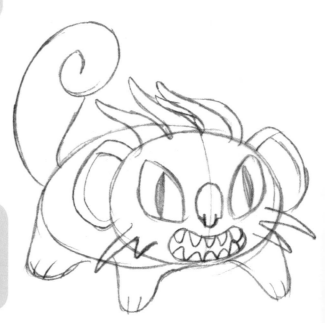

STAGE 3
Draw two thick whiskers below the eyes, then add two large ears and four thick, wavy strands of hair on the top of the head. Finish off the face with a large oval nose.

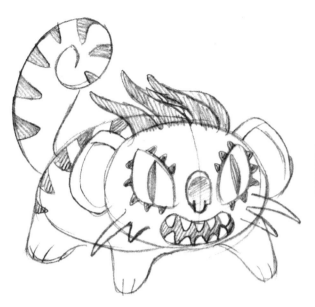

STAGE 4

Put some detail in your punker with some stripes like a tiger, and bold markings around the eyes.

STAGE 5

Ink and colour in hot pink, with black and grey stripes and yellow eyes. Colour the inside of the mouth deep red. Build your colours in rough strokes to add impact.

Grabbler

The grabbler would like nothing more than to use its multiple arms to give you a big hug. Beware, however – once he's on you his belly plate opens to reveal a host of tentacles which worm their way into every orifice, squirting a thick dissolving paste to melt down your insides. Yuck!

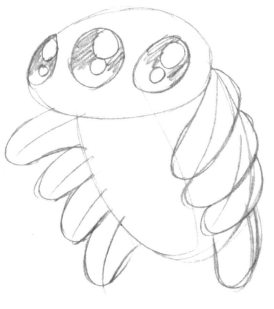

STAGE 1
Start by drawing two ovals, one on top of the other and horizontal. The lower one is leaning left in line with the centre line here.

STAGE 2
Add three large eyes across the top oval, and draw a row of four legs on either side. The bottom two legs are standing on the ground.

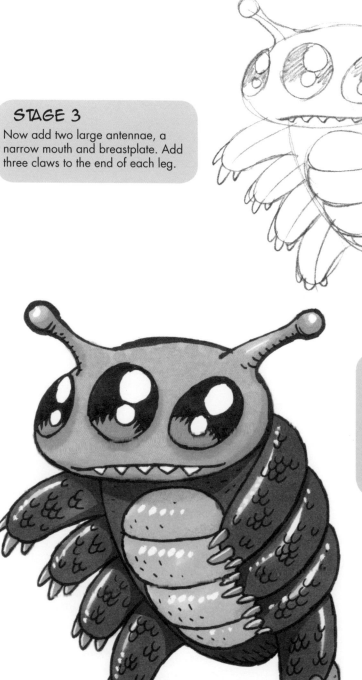

STAGE 3

Now add two large antennae, a narrow mouth and breastplate. Add three claws to the end of each leg.

STAGE 4

Ink and colour in green and yellow, with a paler green for the breast plate. Use a black pen to add a suggestion of scaly texture to the body.

Ghost belcher

A transparent, noxious-fume squirting bundle of pinkness!

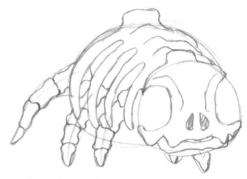

STAGE 1

Start by drawing two overlapping ovals, and add a tail shape and legs.

STAGE 2

Sketch a skeleton, with ribcage, skull and bones, within the ovals, legs and tail. Add a small volcano shape on the back.

STAGE 3

Next, draw an irregular line around the outside of the figure, and draw a spurt of liquid erupting from the opening on the ghost belcher's back.

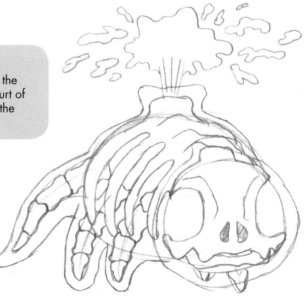

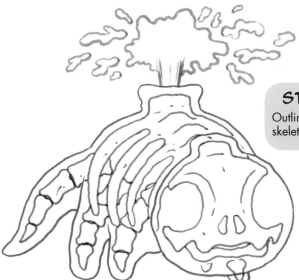

STAGE 4

Outline the body shape in purple, and the skeleton and the spurt in dark grey.

STAGE 5

Colour the liquid with bright green, and the body pink, leaving the skeleton white. Fill in the eyes, nostrils and mouth black. Using a coloured pencil in deep red, shade in the edges of the transparent body. Lastly, use some white paint to add some highlights.

Horned kangarabbit

Master of disguises, the horned kangarabbit's brightly-coloured spots contain a pigment which alters the lightwaves around its body, making it almost invisible to the naked eye. It can hop vast distances in its hunt for food, so don't think you can out-run it – you will be in for a nasty shock.

STAGE 1

Start by drawing a pear-shape with the top drooping over to the left. Sketch an open mouth shape under the droop.

STAGE 2

Now draw a large eye with two tall ears. Add a thick tail at the base of the body, curling up, and mark it with concentric lines.

STAGE 3

Add two arms and leg shapes. Draw three blunted claws on each paw, menacing teeth in the mouth and a single horn mounted on the snout.

STAGE 4

Draw large polka dots over the body. Note how you only see a semi-circle at the edges – this helps the viewer to see it as a rounded, three-dimensional shape.

STAGE 5

Ink and colour in bright blue for the spots, and pink for the tail and inside ears. Finish off with a bright green in the eyes.

MECHA!

Now let's have a look at the mighty mechanical warriors of manga and anime – mecha! The word *mecha* is an abbreviation of the word mechanical, and you pronounce it just as it looks: 'mek-ka'. Sometimes known as giant robots, or *robotto*, mecha are typically armoured fighting suits, usually piloted by a human controller who sits in a kind of cockpit in the chest or head area.

The mecha genre in manga also encompasses sci-fi style stories involving mechanical weaponry or technology such as battlesuit exoskeletons, advanced weaponry and android or cyborg characters. In this section we take a look at how to draw everything from giant mecha warriors, to war-bots, cyborgs and futuristic mecha vehicles.

BATTLESUITS

The most familiar mecha characters resemble a large humanoid robotic figure, with a recognisable head, body, arms and legs. On top of that may be any number of other appendages such as antennae, wings, weaponry and attachments.

Mecha can also refer to battle tanks and planes, but the classic mecha figure as we think of it will sport the basic humanoid set-up of legs, arms, a body and a head section.

Over the years these battlesuits have become more and more complex, and modern versions can sport a bewildering arrray of antennae, wings, fins and the like. Some have developed as very slimline and graceful, while others are bulky and laden with weapons.

In Japan, these figures are so popular that you can see giant-sized replica figures in theme parks, and robot enthusiasts and inventors are continually striving to develop real-life battlesuits inspired by their mecha heroes.

I'M A MECHA-MONKEY!

BATTLESUITS, LIKE KAIJU, ARE USUALLY HUGE FIGURES THAT DWARF THEIR HUMAN PILOTS AS WELL AS THEIR SURROUNDINGS. THIS GIANT MECHA HAS WARNING LIGHTS ON HIS ARMOUR TO LET LOW-FLYING AIRCRAFT KNOW HE'S THERE.

MECHA HEAD

Let's start by looking at a typical mecha head.
I do not use a ruler for the straight, lines but feel
free to do so if you prefer.

STAGE 1
Begin with a rough rectangular
block, smaller at the bottom and
with a central dividing line.

STAGE 2
Draw an eyebrow area,
narrowing towards the centre
and with two rounded triangular
sections running to the rear as
shown. Add a rounded diamond
shape to the front, with the
thinner point at the bottom.

STAGE 3
Next, sketch a suggestion of cheek shapes on either
side, with protruding triangular 'ears'. Draw a
suggestion of the top of the head between the two
triangular shapes and add a detail crest.

STAGE 4

Add rectangular slots for eyes, and draw in detail on the cheeks and either side of the eyes. Add a tip section to the chin and two circular lights on the forehead area.

STAGE 5

Ink and colour your drawing, using a contrasting colour-scheme like this maroon and white version. A good way to put extra colour into white areas is to use mauve tones. If the area around the eyes is dark, you can leave the eyes white or bright yellow to look as if the mecha is switched on and alert. A little white paint on the highlights can make your drawing stand out.

HUMANOID MECHA HANDS AND FEET

HANDS
The hands of these mecha are typically
constructed in the same way as human hands,
with a palm area, fingers and thumb.

THE PALM AND BACK
OF HAND ARE SOLID
RECTANGULAR BLOCKS.

THE FINGERS ARE FLAT,
JOINTED SLABS, WHICH GRIP
AND FOLD IN THE SAME WAY
NORMAL FINGERS DO.

USE DIFFERENT
COLOURS TO
HELP DISTINGUISH
THE FINGERS AND
PALM VISUALLY.

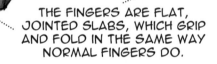

THE FOREARM IS
COMMONLY COVERED BY A
LARGER 'GAUNTLET'.

FEET

Mecha feet need to be large and bulky to support the enormous weight of the metal suits. Unlike shoes, they tend to slope down to the base at an angle, and finish with a broad flat platform.

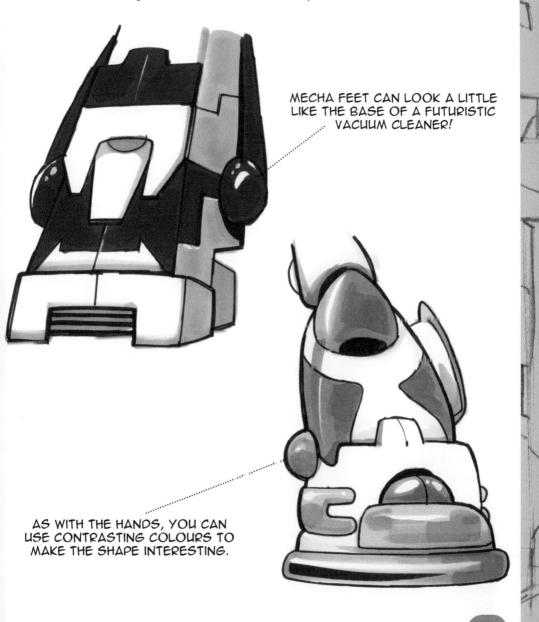

MECHA FEET CAN LOOK A LITTLE LIKE THE BASE OF A FUTURISTIC VACUUM CLEANER!

AS WITH THE HANDS, YOU CAN USE CONTRASTING COLOURS TO MAKE THE SHAPE INTERESTING.

Basic battlesuit

Apart from its overall size and a variation in the relative size of certain parts, mecha are often based on the same structure as a human being. Let's look at how you construct a typical mecha battlesuit, starting with a simple wire-and-box frame skeleton.

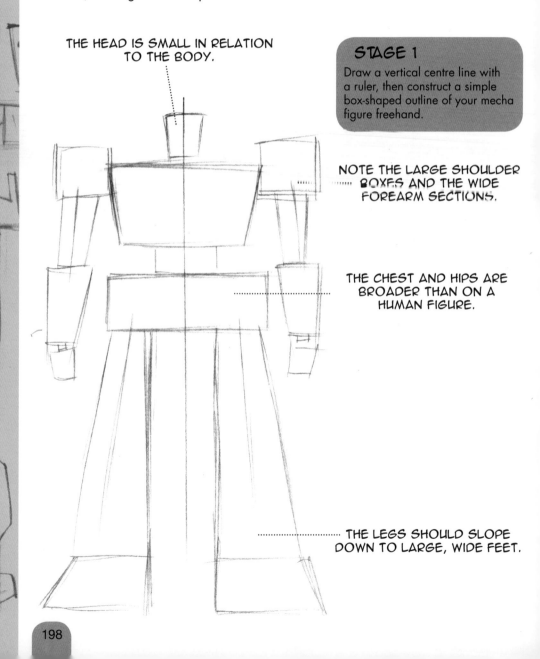

THE HEAD IS SMALL IN RELATION TO THE BODY.

STAGE 1
Draw a vertical centre line with a ruler, then construct a simple box-shaped outline of your mecha figure freehand.

NOTE THE LARGE SHOULDER BOXES AND THE WIDE FOREARM SECTIONS.

THE CHEST AND HIPS ARE BROADER THAN ON A HUMAN FIGURE.

THE LEGS SHOULD SLOPE DOWN TO LARGE, WIDE FEET.

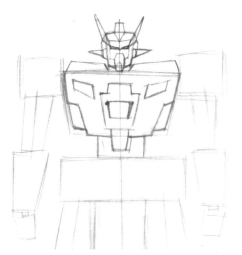

STAGE 2

Start to sketch in the head and chest section. Keep these symmetrical and use details on the head and body to draw the eye down to the centre line.

STAGE 3

Work your way down the arms and waist areas, adding interesting section shapes to the armour, such as fins and joints. Draw two clenched fist hands, which are small in comparison with the arms and torso – this gives a sense of intimidating size to the figure itself.

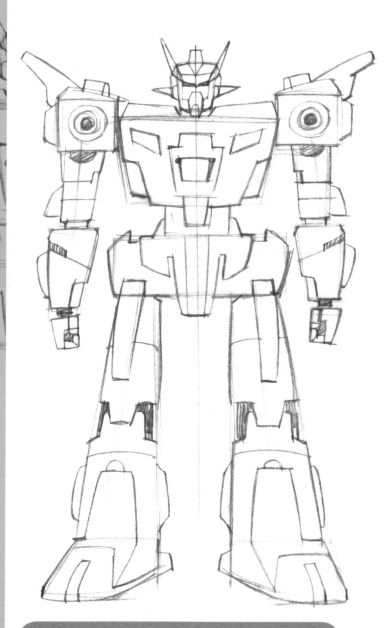

STAGE 4

Continue working down to the feet, adding joints and cutaway sections as you go. Always remember that the art is to make the viewer believe it really could be a moving, mechanical figure, so any joints and shapes you add to your mecha must have an air of implied functionality.

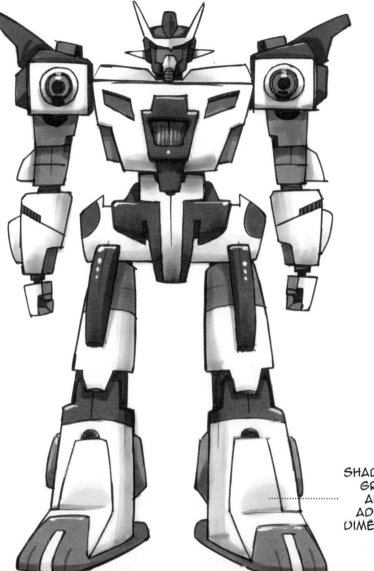

SHADING IN PASTEL GREYS, BLUES AND MAUVES ADDS A THREE-DIMENSIONAL FEEL.

STAGE 5

Ink and colour your mecha in contrasting colours, like this one in red, white and grey. In this drawing the red is the strongest colour, so I have used that on some of the smaller details. Using a dark grey on some parts pushes those areas into the background, and makes the white areas stand out more.

201

Slimline mecha

Some battlesuits cut a more graceful silhouette built for agility. Here is a typical slimline mecha, less bulky and more closely resembling the human figure than the heavier mecha earlier.

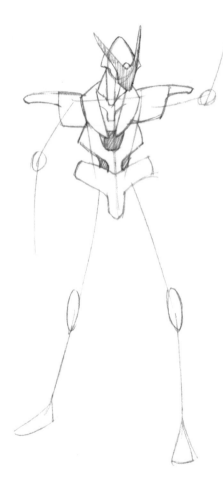

STAGE 1

Start with a tall wireframe figure, standing with one arm raised. Draw in areas for shoulders and torso, and add a Y-shaped groin piece.

STAGE 2

Add detail to the face, neck and chest area as shown. All the different pieces of chest and shoulder armour should draw the eye down to the centre. Add a 'wing' shaped face visor.

STAGE 3

Start adding details to the arms, with oversized but sleek gauntlets. Draw some more fins protruding from the character's back.

STAGE 4

Finish your sketch by drawing in long, slender legs, with flared knee-guards.

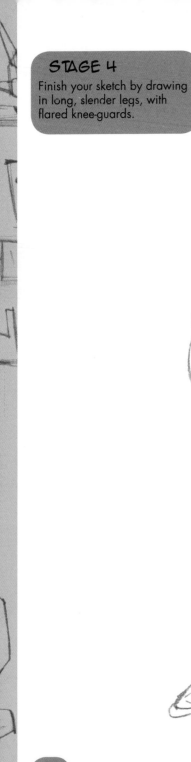
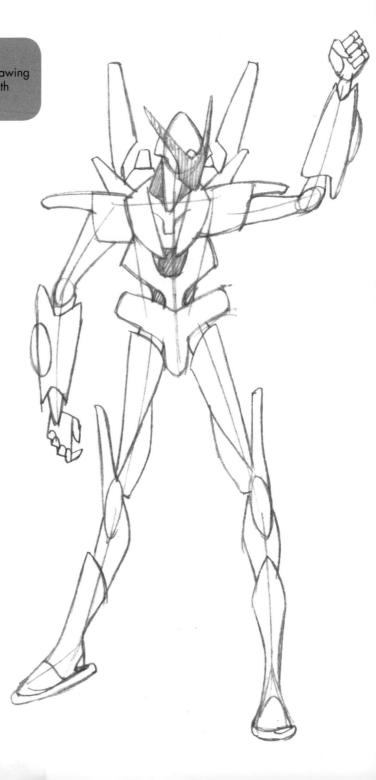

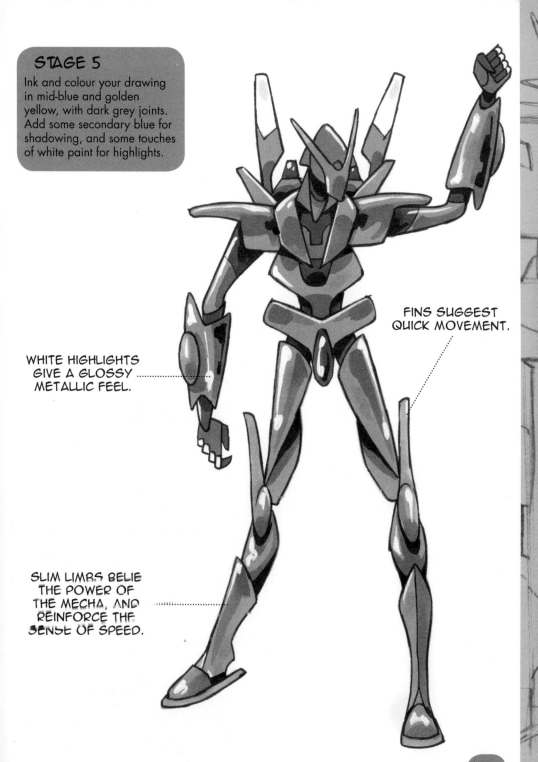

STAGE 5

Ink and colour your drawing in mid-blue and golden yellow, with dark grey joints. Add some secondary blue for shadowing, and some touches of white paint for highlights.

FINS SUGGEST
QUICK MOVEMENT.

WHITE HIGHLIGHTS
GIVE A GLOSSY
METALLIC FEEL.

SLIM LIMBS BELIE
THE POWER OF
THE MECHA, AND
REINFORCE THE
SENSE OF SPEED.

WAR-BOTS

Mecha don't just rely on their good looks to win a fight – they also sport a wide range of weaponry, including swords, guns, rocket launchers, lasers and grenade launchers. Here are some examples of weaponised mecha!

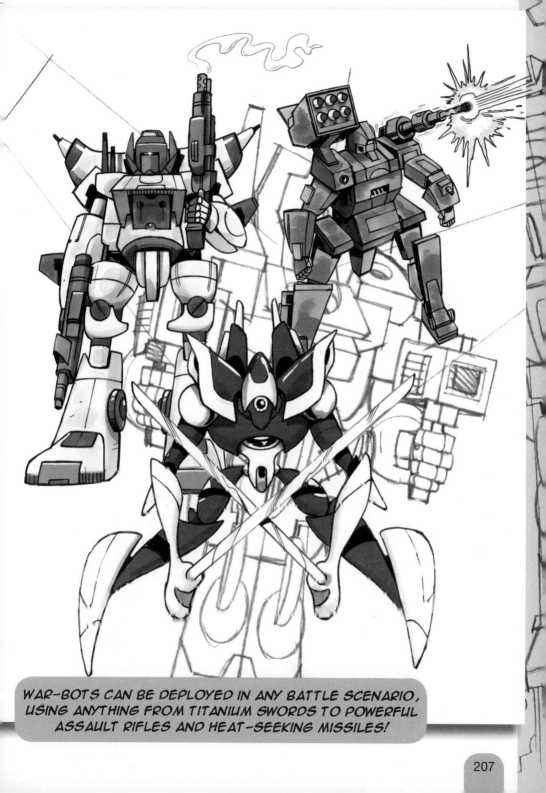

WAR-BOTS CAN BE DEPLOYED IN ANY BATTLE SCENARIO, USING ANYTHING FROM TITANIUM SWORDS TO POWERFUL ASSAULT RIFLES AND HEAT-SEEKING MISSILES!

MECHA WEAPONS

Mecha weapons can resemble conventional human weapons, but bigger and heavier-looking. A mecha warrior can carry a lot of weight, so bulky, industrial-strength tech is usually the order of the day. Slimline mecha can also carry swords like the traditional *katana* or more modern laser sabre. Overall, it's best to colour their weaponry in dull, neutral greys to give a rugged, utilitarian look.

ASSAULT RIFLE
High-powered and bulky, this is perfect for high-speed attack.

WRIST BLASTER
Convenient for use when you rush into battle and forget your rifle!

ROCKET LAUNCHER
Shoulder-mounted and filled with heat-seeking missiles.

GIANT DEMON-SWORD
A glittering blade: perfect for dispatching mystical and supernatural enemies.

LASER SABRE
This will cut through anything – even tempered steel and reinforced concrete.

DETACHABLE CANNON
This can be mounted as part of armour or simply carried.
It delivers high velocity armour-piercing shells.

HAND-HELD BLASTER
Ideal for close-range combat situations.

ARMOURED SHIELD
Defensive equipment is useful. This
shield will even deflect cannon fire.

MULTI-PURPOSE DAGGER
For use when things get up close
and personal!

KATANA
The traditional Japanese sword is
favoured by some mecha.

Laser mecha knight

This laser mecha knight is a super-armoured warrior of the old guard. His long, thin laser sword can cut through anything with a single swipe, while his triple-thickness armour provides a resilient defence against attack.

STAGE 1

Sketch a wireframe mecha shape with both hands in front, clasping a sword. The stance is in mid-attack, so its right leg should be on the ground while the left is folded back at the knee.

STAGE 2

Add a rear back section and draw a variety of fins, extensions and panel shapes on the arms and leg sections.

SHOW BLACK SHADOWS CAST BY THE LASER.

ADD FINE LINES OF WHITE PAINT TO MAKE THE ARMOUR PANELS REALLY POP OUT!

STAGE 3

Ink and colour in greys, brick red, blue and yellow. Outline the laser sword in a bright aqua blue and put a pale blue wash around it for a bright laser glow. Leave some highlights on the armour to suggest light from the laser, and once you have a mid-grey covering on the whole figure, use some colours over it for a metallic finish.

Bloodhound mecha

This mecha uses extremely sensitive sensory filters to track its enemies across the terrain.

STAGE 1

Start by drawing a mecha head with large shoulder units and a triple exhaust unit mounted on the back. Set the left arm pointing downwards and the right one bent at the elbow.

STAGE 2

Draw the right leg bent at the knee and foreshortened so it is in the foreground. Fill out the arm sections and add hands, with the right hand in a gripping position.

STAGE 3

Complete the drawing by adding details to the arms and shoulders, and draw an axe in the right hand. Sketch some exhaust plumes at the back and indicate some wires in the legs and arms.

STAGE 4

Ink and colour in yellow with dark grey contrast, then fill in some strong black shadows to give your drawing more impact. Add red to the wires and shoulder struts, and build up shadows and highlights with darker yellows and white paint.

Sword mecha

This mecha has short wing struts for high-velocity aerial attack.

STAGE 1

Start with a figure in an X-shaped stance, with a mecha head and chest section in the centre. The right leg is bent, so finish that at the knee.

STAGE 2

Build up the area around the head and shoulders with multiple fins, aerials and short wings, all radiating from the centre.

STAGE 3

Add details to the arms and legs, and draw a large stylised sword in the mecha's right hand.

STAGE 4

Ink and colour in green and grey, with yellow contrasting areas. Use some solid black areas to define the darkest shadows. Use a couple of minor spots of red to give the drawing interest. A red collar draws the eye to the head.

Airborne gunfighter mecha

Despite the weight of their heavy armour, some mecha are equipped with wings and possess the ability to fly. They might not be particularly agile in the air but with the right weaponry they can make a fearsome aerial assault!

STAGE 1

Start with a simple 'Y' shape, positioned around a centre line running on a diagonal. On the two upper arms, reduce the width of the shape as it nears the tip. On the lower arm, the tip is wider.

STAGE 2

Sketch in a head and shoulders. Take your time and build it up slowly – the more detail the better.

STAGE 3

Continue drawing in the body and legs, down to the feet. Aim to make the two sides more or less symmetrical. Add two small wheels on the hips, for use on the ground.

STAGE 4

Draw a large, squared-off gun in each hand. Notice how the arms are bent at the hip, so you only see the hand and a glimpse of forearm beyond.

217

STAGE 5

Finish your drawing with some exhaust lines propelling the mecha up into the air!

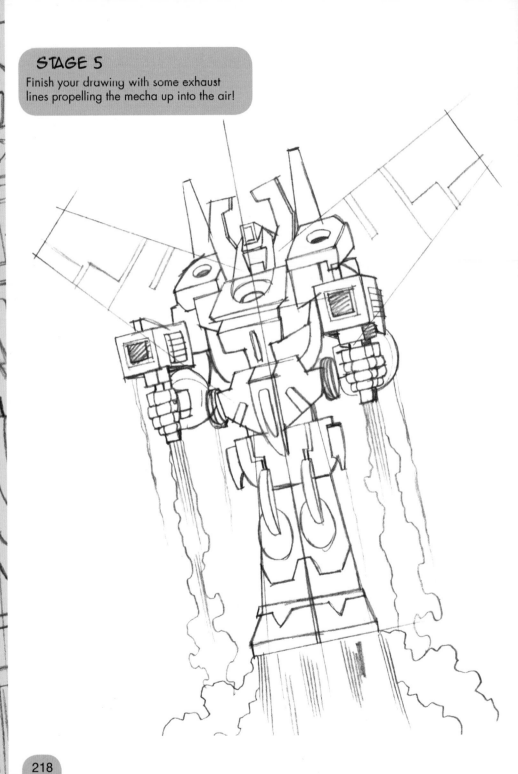

PANEL LINES ADD INTEREST TO
LARGE FLAT AREAS.

THESE LINES
REINFORCE THE
DIRECTION OF
TRAVEL.

STAGE 8

Ink and colour your drawing
in mauve and lilac, with mid-
greys and reds for detailing.
Use a sepia colour to outline
the smoke, and a pink or
purple pencil to add some
movement lines.

THE WARM SMOKE COLOURS
CONTRAST WITH THE COOL PURPLES
OF THE MECHA.

Sword-wielding mecha

As tough as their mighty armoured bodies are, some mecha also choose to use traditional weapons in their battles. Here we are going to draw an attacking mecha armed with a giant-sized sword – get out of the way!

STAGE 1

Sketch out a wireframe figure in a running pose, with oversized shoulder sections and long limbs.

STAGE 2

Draw a large sword, with the handle in the mecha's left hand and the right hand resting on the blade. Use a ruler for this part of the drawing.

STAGE 3

Sketch in a mecha head and shoulders, with multiple head spikes and shoulder blades. Move down to the torso and draw a chest plate and ribbed under-section.

STAGE 4

Move on to drawing out and detailing the arms and legs. The left leg is folded and hidden by the sword, and the right leg ends in a broad shock-absorbing base. Add fins on the legs and jointed elbows and knees.

STAGE 5
Add more details to your figure then, using the groin area as the vanishing point, draw radiating speed lines with a ruler.

STAGE 6

Ink and colour your drawing in dark greys and red, with mauve on the speed lines and pale blue on the sword blade. Add some highlights with white paint.

Assault mecha

Some mecha are fully equipped for more intense battleground combat, with multi-functional weapon systems. Here's a bulky war-bot mecha with hand blaster, rocket launchers and wrist cannon.

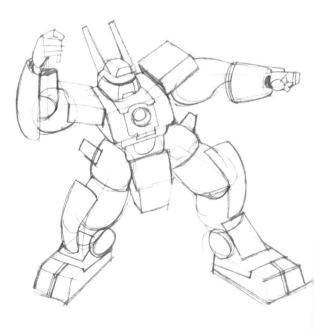

STAGE 1

Start with a rough wireframe sketch of a mecha in an action stance, with its right arm raised with gripping hand and its left arm pointing out straight with its fist clenched.

STAGE 2

Next, build up a bulky mecha suit with lots of details including helmet fins, knee guards, ankle gears and chest power point.

STAGE 3

Add a hand-blaster shooting upwards, a shoulder-mounted rocket-launcher firing two missiles flying outwards towards the top right corner of the page, and a wrist-mounted cannon firing off horizontally. Indicate a piece of rough ground with a few simple jagged lines.

STAGE 4

Ink your drawing in black, with red lines around the explosive blasts and a brown for the ground outline. Use the same brown to add some scattered rocks.

STAGE 5

Colour parts of the armour in grey and blue, leaving some parts white as shown.
Use a darker grey for the weapons, and a bright red on the missile heads.

STAGE 6

Finish with some shading tones and build it up with repeated marker strokes to give a rough, patchy look. Add orange and yellow to the blast explosions, then use a black brush pen to ink fragment spray around the blasts. Use a dull warm grey on the ground with rough strokes, leaving a bit of white around the mecha feet.

MECHA VEHICLES

The genre of mecha encompasses all kinds of fighting machinery as well as the Robotto-style characters. Manga, such as *Appleseed* by Masamune Shirow for example, features stories involving hi-tech weaponry and vehicles utilised by an urban police force, keeping the peace in a post-world-war-three cyberpunk world. Such mecha can often be based on existing vehicles like jet fighters, tanks and helicopters, or maybe take the shape of an entirely new form which is yet to be invented! In this section we will look at some dynamic examples!

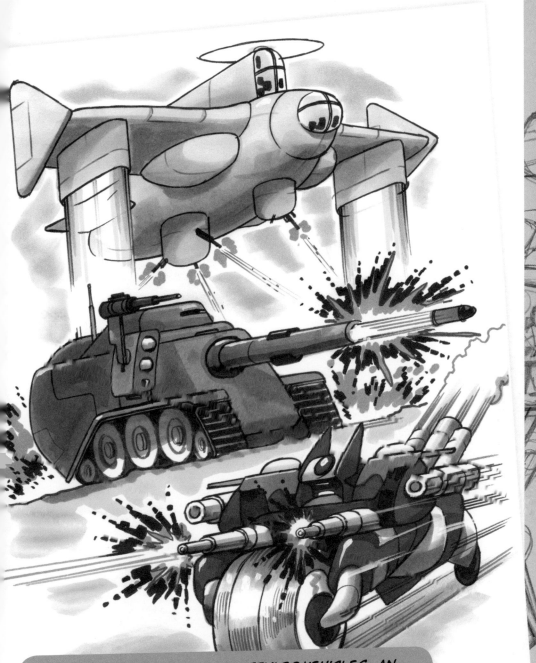

HERE'S A TRIO OF MECHA-STYLED VEHICLES: AN AIRBORNE DEPLOYMENT CRAFT, A HEAVILY-ARMOURED BLAST TANK WITH CATERPILLAR TRACKS, AND A HIGH-SPEED, CANNON-EQUIPPED CYCLE-BOT.

MECHA VEHICLE FEATURES

Mecha vehicles should look futuristic but functional, and it's important to add lots of detail which will help to make the viewer believe they can really move, while also making the shape interesting and exciting enough to spice up the story. Here are some examples of details you can add to your vehicle. See if you can invent your own unusual but practical features!

RED WARNING LIGHT
A flashing coloured light for emergency vehicles also looks good on mecha.

SOLID ROUND WHEEL
Great for high speed and quick changes in direction.

ROUGH TERRAIN WHEEL
This rugged wheel would suit mecha for mountain and off-road use.

ROTOR BLADE
This allows vehicles to take off and land vertically.

COCKPIT
Mecha can have a cockpit like an aeroplane. It should be dimly-lit with the pilot in shadow and a green or yellow glow from the instruments

ARMOURED PANEL
This panel protects the vulnerable air vent – used to cool the engine – beneath.

BOOSTER

This provides the main downward thrust for heavy vehicle launch.

EXHAUSTS

Triple rear-mounted exhaust pipes look powerful when spewing smoke and flame.

SURFACE DETAILS

Radars, aerials, screws, pistons and intake ducts all make good detail touches.

LEGS

This knee section for a jointed leg, shows hydraulic cables and a protective guard plate.

ENTRY HATCH

Vacuum-sealed flush to the main body, the pilot or driver can use this to get into the mecha.

Groundhog all-terrain vehicle

Along with thick armour shields and a top-mounted cannon, this all-terrain vehicle has super large wheels and tyres to go over any surface.

STAGE 1

Sketch a roughly rectangular wireframe with rounded corners and sloping rear end, then add two circular wheels at the front and one partially hidden rear wheel.

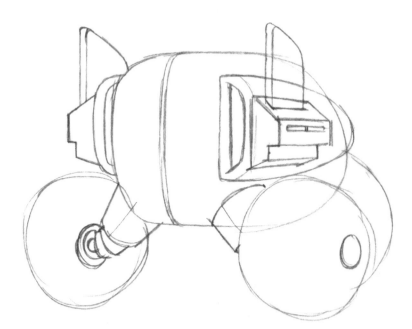

STAGE 2

Draw telescopic struts to each front wheel and add side vents with protective armour shields raised.

232

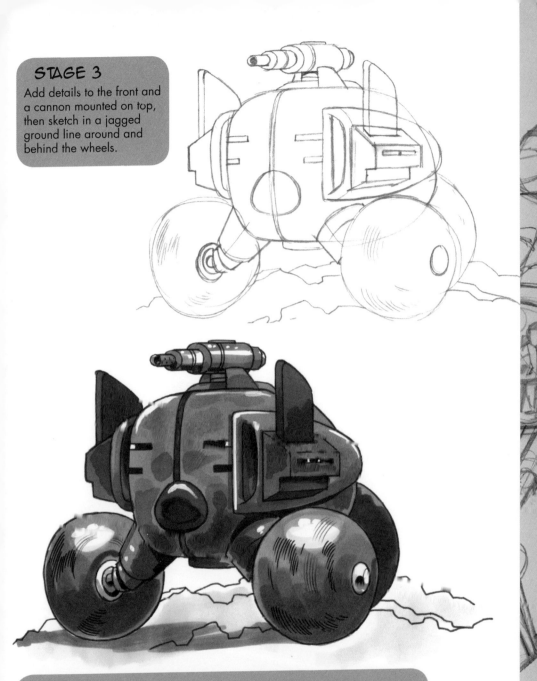

STAGE 3

Add details to the front and a cannon mounted on top, then sketch in a jagged ground line around and behind the wheels.

STAGE 4

Ink and colour in mid-brown, red and grey, leaving white highlights on the two front wheels. Add a shadow on the ground and build up darker areas of tone under the body and the tyres.

High-speed patrol bike

Built for speed, this streamlined pursuit bike can patrol large areas swiftly and effectively, with a high-intensity searchlight and powerful weapons.

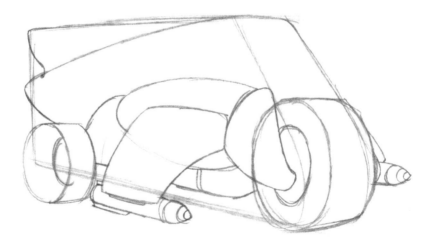

STAGE 1
Draw a rectangular block with a sloping front and single front wheel, then add a rear side wheel.

STAGE 2
Divide the body into a downward sloping section and tail fin, then draw a central turbo unit with ground wings ending in a missile. Add a connecting strut to the front wheel.

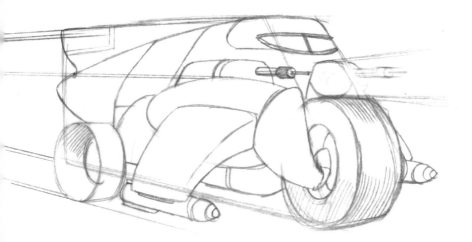

STAGE 3

Next, draw a front visor section and twin mounted velocity guns. Indicate a central front search beam, and add speed lines and light beams.

STAGE 4

Ink and colour in yellow with dark grey wheels, and use a pale blue to line in the light beam. Colour the velocity gun behind the beam in pale grey so it appears faint and knocked-back, and continue the speed lines with grey and yellow as shown.

Floating battle station

A high-altitude command and attack station like this can hover above the battle and pinpoint trouble far below, launching multiple supporting attacks with cannons, missiles and machine guns.

STAGE 1

Start with a single rectangular block tapering at the top, and add two small side blocks and a front wedge as shown.

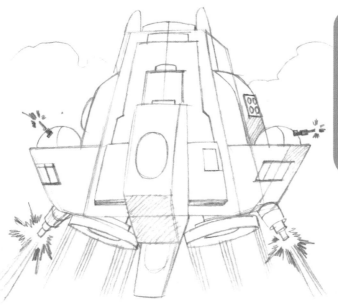

STAGE 2

Add panel details to the front, then draw two downward propulsion fans flanked by cannons. Draw two spherical machine gun turrets on either flank and build up the shape with extra side panels and structures.

STAGE 3

Add a side-mounted rocket launcher and two more small gun-turrets, before shading and adding a missile being launched. The more details you can add here, the better!

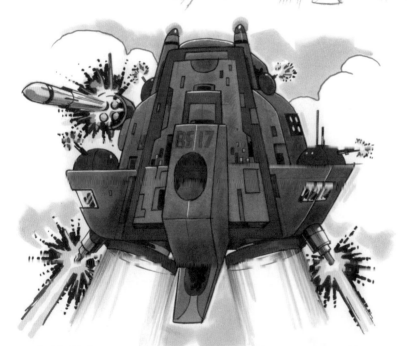

STAGE 4

Ink and colour the station with dark grey and use red for detail. Build up the shading and add a panel of yellow on either side of the large central opening. Use red, orange and yellow around the firing guns.

Elevated scout module

These kind of vehicles are often called 'Chicken Walkers' after their resemblance to the way a chicken walks. They appear in many films, from *Star Wars* to *Robocop*.

STAGE 1

Begin with a wireframe oval with triple-sectioned legs, then add four smaller ovals at front, sides and top of the larger one. Note how the first leg section points backwards before pointing down to the knee joint.

STAGE 2

Sketch in twin cannons on either side of the body, and build up the legs with mechanical struts and joints. Draw wedge-shaped feet, and sketch a cockpit window at the front where the pilot will sit.

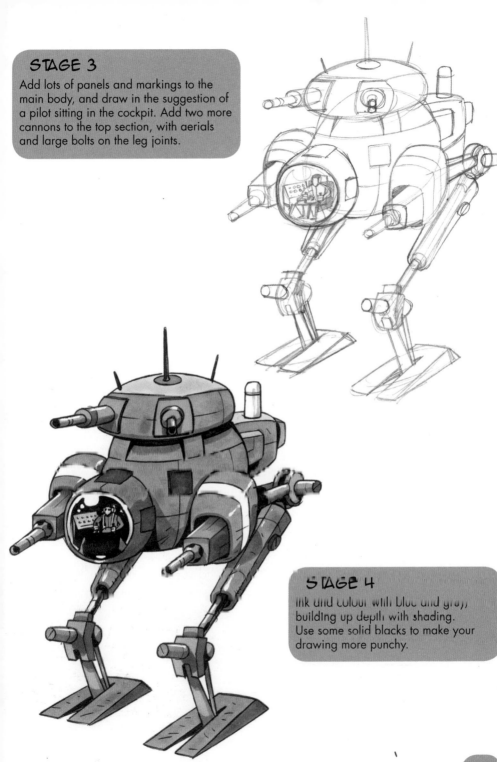

STAGE 3

Add lots of panels and markings to the main body, and draw in the suggestion of a pilot sitting in the cockpit. Add two more cannons to the top section, with aerials and large bolts on the leg joints.

STAGE 4

Ink and colour with blue and grey, building up depth with shading. Use some solid blacks to make your drawing more punchy.

CYBORGS

The idea of mixing up man and machine has long been a popular subject in science-fiction stories. The term 'cyborg' was invented in 1960, to describe as a person with both organic and mechanical – or 'biomechatronic' – parts. At the time it was virtually science fiction, but nowadays it is becoming relatively common to replace faulty or damaged limbs and organs in the human body with mechanical parts – everything from pacemakers to literal bionic arms – which help people function more normally in everyday life.

In the 1970s, a popular television series called *The Six Million Dollar Man* featured a man given extraordinary abilities through mechanical augmentation, giving him super-strength, vision and speed. Cyborg-type characters have featured in many other television programmes and films such as *Doctor Who*, *Star Trek* and *Star Wars*.

This trend is relatively common in manga. The series *Fullmetal Alchemist* by Hiromu Arakawa, for example, features a character called Edward who has an arm and a leg replaced with advanced prosthetic limbs; and his brother, Alphonse, is essentially a mobile suit of armour!

In this section we will look at a few examples of humans who have benefited from mechanical enhancements like those described.

IT'S TOO HEAVY TO LIFT!

CYBORG MECHA FEATURES

When it comes to augmenting the human body, there are pretty much no limits as to which parts you can improve with some bio-mechanical additions!

Protective brain shield with electric modular stimulation.

Sonic ear receiver with three-mile hearing radius.

Cerebral cortex connection to spinal cord.

ENHANCED CYBERNETIC SKULL

BIONIC ARM REPLACEMENT

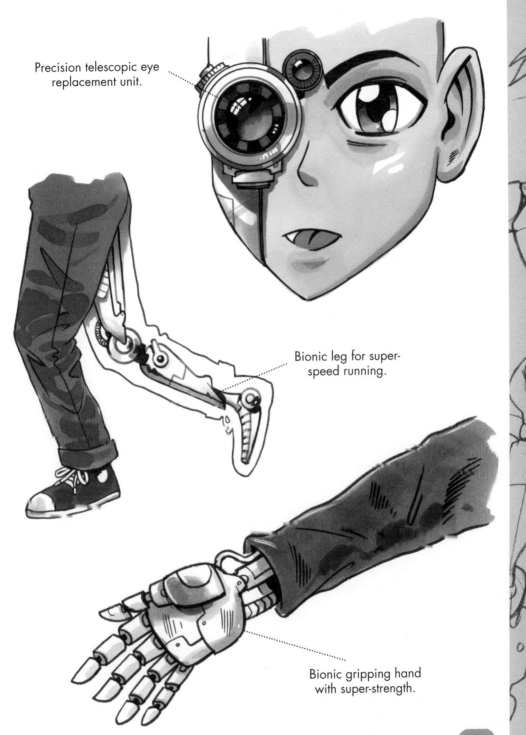

Precision telescopic eye replacement unit.

Bionic leg for super-speed running.

Bionic gripping hand with super-strength.

Cyborg patrol

This cyborg is fully equipped with the latest in combat tech.
Barely recognisable as human, the exposed area of the face
shows there is a human being in there somewhere!

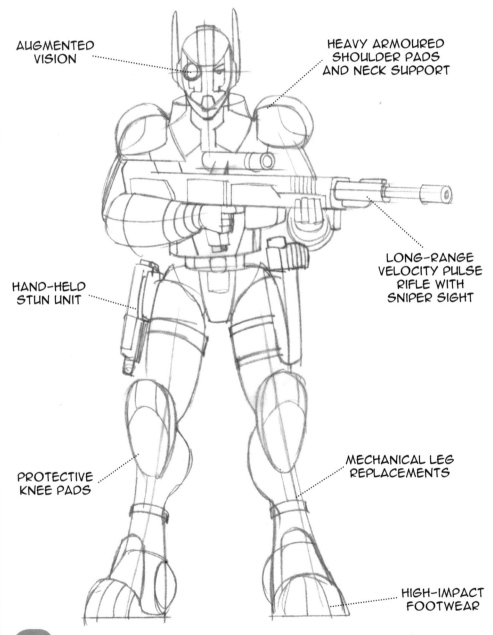

AUGMENTED
VISION

HEAVY ARMOURED
SHOULDER PADS
AND NECK SUPPORT

LONG-RANGE
VELOCITY PULSE
RIFLE WITH
SNIPER SIGHT

HAND-HELD
STUN UNIT

PROTECTIVE
KNEE PADS

MECHANICAL LEG
REPLACEMENTS

HIGH-IMPACT
FOOTWEAR

METALLIC BLUE-WHITE
WRIST GUARDS AND
SHOULDER PADS

BRICK-RED
ARMOUR PLATES

HIGH CONTRAST
MARKS, FOR
A REFLECTIVE
EFFECT, ARE
ADDED WITH A
BLACK BRUSH PEN

INK IN SOLID BLACKS
FOR THE UNDER-
TUNIC AND STRAPS
ON THE LEGS

GREY TRIM
CONTRASTS
EFFECTIVELY WITH
THE RED PLATES

SHADOW MARKS
MADE WITH GREY ON
THE RED ARMOUR GIVE
A WORN, USED LOOK
THAT ADDS REALISM

Augmented human

One day, all humans may sport bio-mechanical appendages to increase their combat efficiency. This teenager has a replacement leg and fist to enhance her running speed and pack a mighty punch!

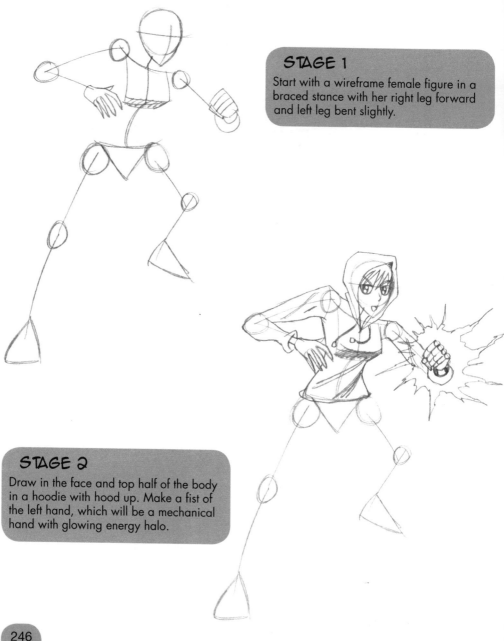

STAGE 1

Start with a wireframe female figure in a braced stance with her right leg forward and left leg bent slightly.

STAGE 2

Draw in the face and top half of the body in a hoodie with hood up. Make a fist of the left hand, which will be a mechanical hand with glowing energy halo.

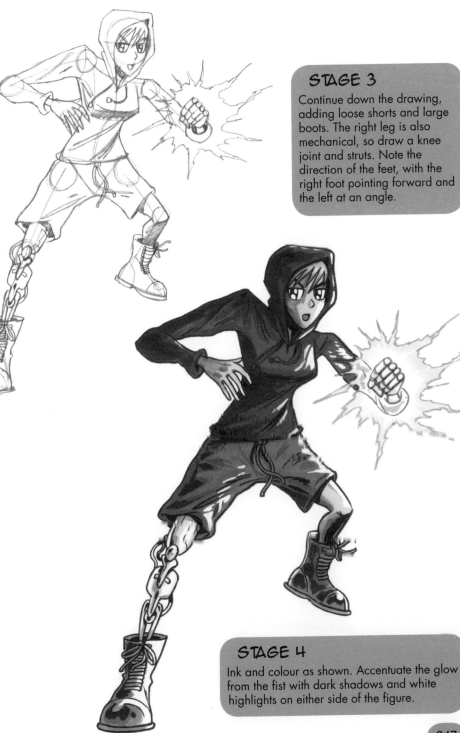

STAGE 3

Continue down the drawing, adding loose shorts and large boots. The right leg is also mechanical, so draw a knee joint and struts. Note the direction of the feet, with the right foot pointing forward and the left at an angle.

STAGE 4

Ink and colour as shown. Accentuate the glow from the fist with dark shadows and white highlights on either side of the figure.

Android

An android is a mechanical or synthetic being with human appearance. This specimen has a human face, and it is being charged with power from a battery terminal before donning synthetic human skin and clothing.

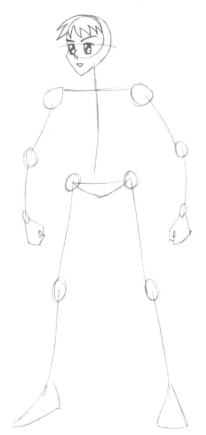

STAGE 1
Draw a wireframe figure standing in a neutral pose, and sketch in the face.

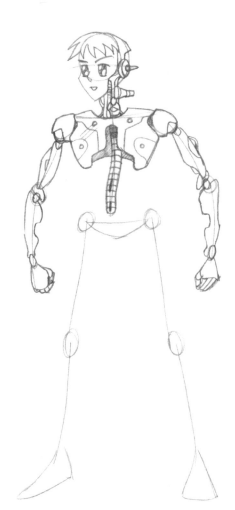

STAGE 2
Behind the face, draw mechanical head and neck details, with ear piece and antenna showing. Add a chest plate and spinal column, and two sectioned arms as shown.

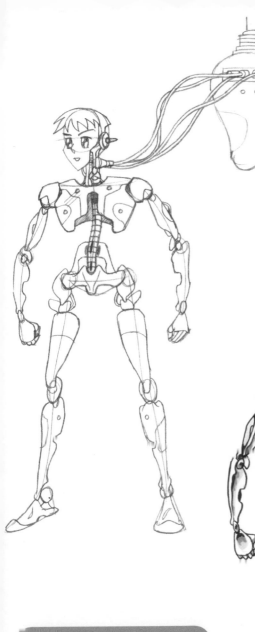

STAGE 3

Draw in a hip and groin section, and continue down with the legs and feet. Add a series of wires running from connectors at the back of the neck, up to a ceiling-mounted charging unit.

STAGE 4

Ink and colour the body in metallic blue and grey, and colour the face mask in normal flesh colour. Add some soft off-white shading to the charger unit to give the impression of a sterile, futuristic tech lab.

Bio-mechanical arm unit

Sometimes we all need a helping hand – but this one takes things to the extreme, with a turbo-charged mechanical gauntlet powered by liquid energy crystals, capable of delivering a shocking grip!

STAGE 1

Sketch a wireframe figure in fighting stance, with an oversized left hand and arm.

STAGE 2

Draw in the human figure with loose jacket, tee-shirt and trousers. Make sure the hair and the garment creases are all leading in the direction of the stance – this intensifies the effect of the hand.

STAGE 3

Next, draw in a large mechanical hand and arm, using foreshortening to exaggerate the size of the hand and increase the impact of the drawing. Add an electric halo around the hand.

STAGE 4

Ink and colour as shown, with a red outline for the electricity and a yellow halo fading to white. Add a hint of yellow to the side of the face, neck and tee-shirt.

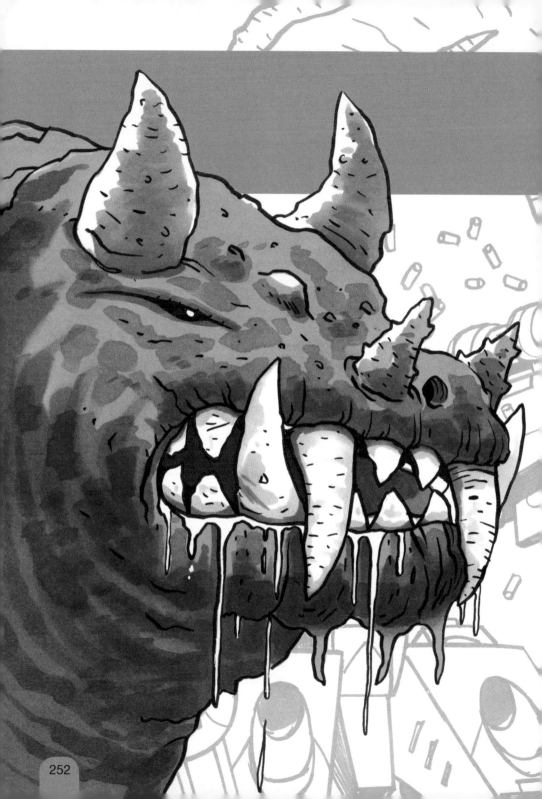

MONSTERS VERSUS MECHA

We've looked at a wide variety of monsters and mecha In this book, but it's inevitable that the two sometimes have to tackle each other head on! Here are four full-page battle pictures you can try – or better yet, draw your own clashes between the mecha and monsters you create.

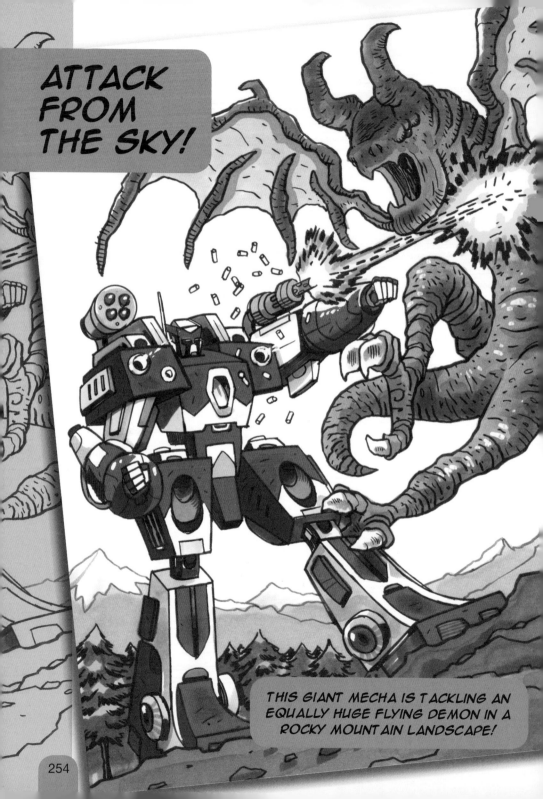

ATTACK FROM THE SKY!

THIS GIANT MECHA IS TACKLING AN EQUALLY HUGE FLYING DEMON IN A ROCKY MOUNTAIN LANDSCAPE!

STAGE 1

Start by sketching a wireframe mecha figure standing in the lower-left corner of the page, making sure you leave space in the top right for your monster. Draw a sloping jagged ground line to indicate an uneven surface.

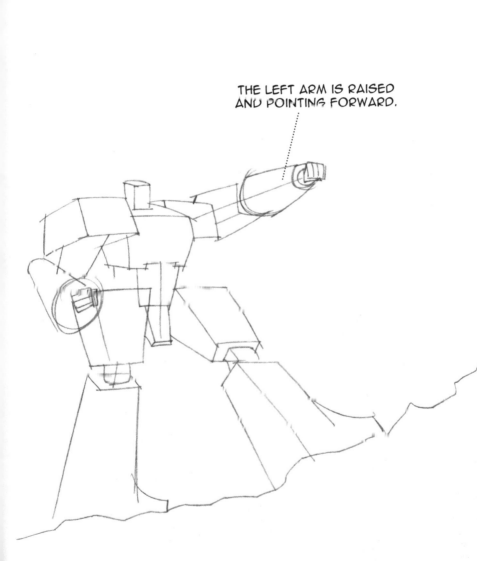

THE LEFT ARM IS RAISED AND POINTING FORWARD.

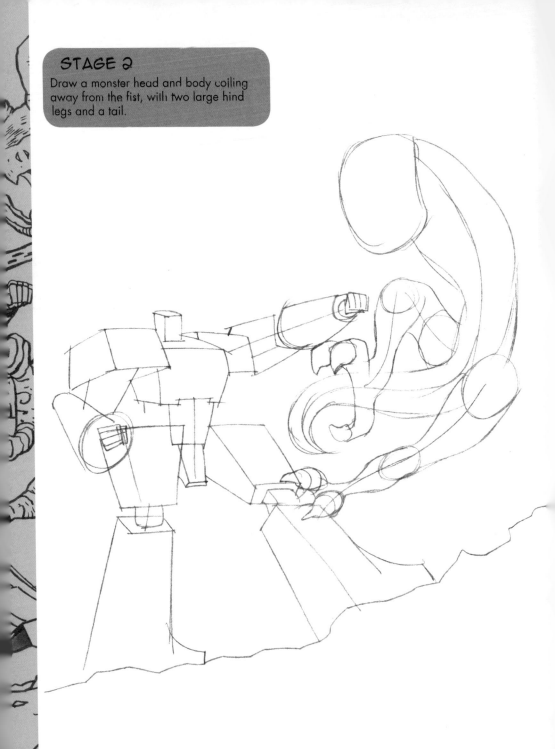

STAGE 2

Draw a monster head and body coiling away from the fist, with two large hind legs and a tail.

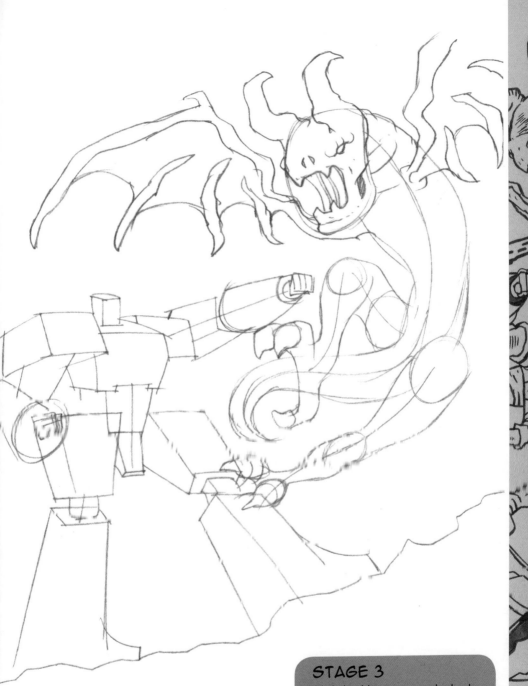

STAGE 3

Add skeletal bat wings to the body, then large horns, a mouth and eyes to the head.

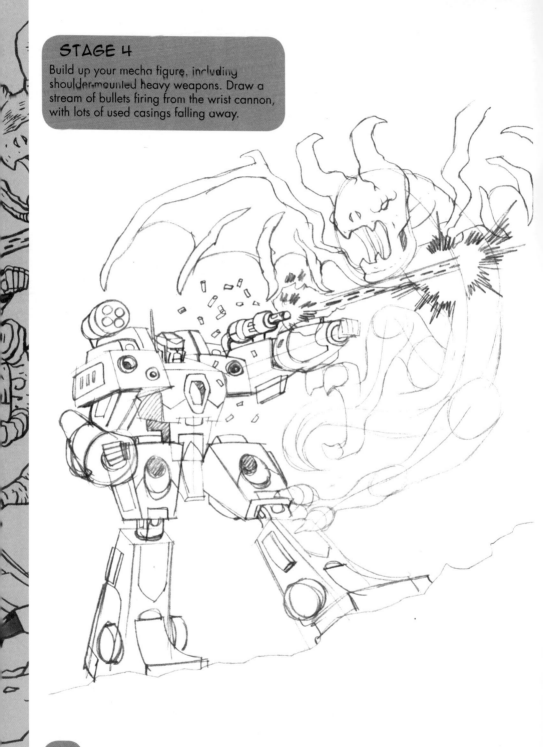

STAGE 4

Build up your mecha figure, including shoulder-mounted heavy weapons. Draw a stream of bullets firing from the wrist cannon, with lots of used casings falling away.

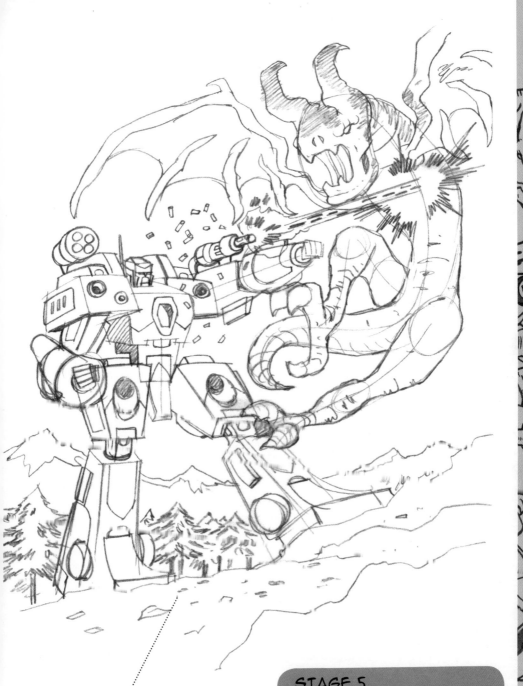

AS WELL AS A SENSE OF SCALE, BACKGROUND FEATURES CAN SUGGEST A PARTICULAR LOCATION.

STAGE 5
Draw some mountain scenery and trees at the base of the figures.

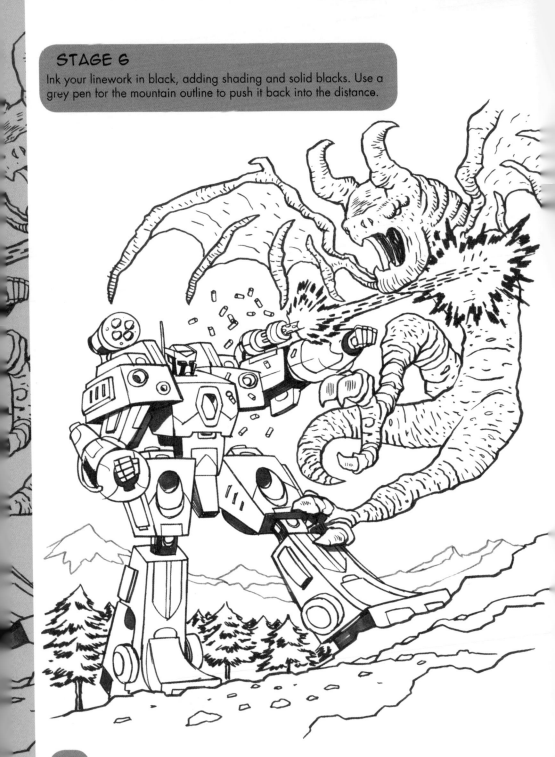

STAGE 6

Ink your linework in black, adding shading and solid blacks. Use a grey pen for the mountain outline to push it back into the distance.

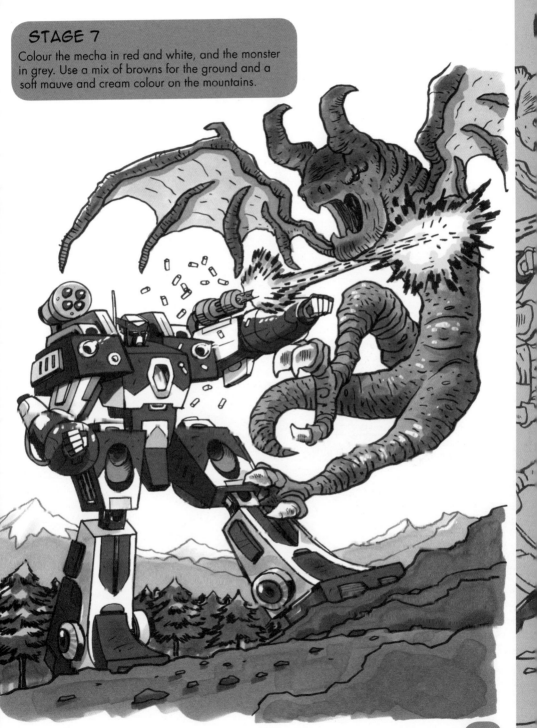

STAGE 7

Colour the mecha in red and white, and the monster in grey. Use a mix of browns for the ground and a soft mauve and cream colour on the mountains.

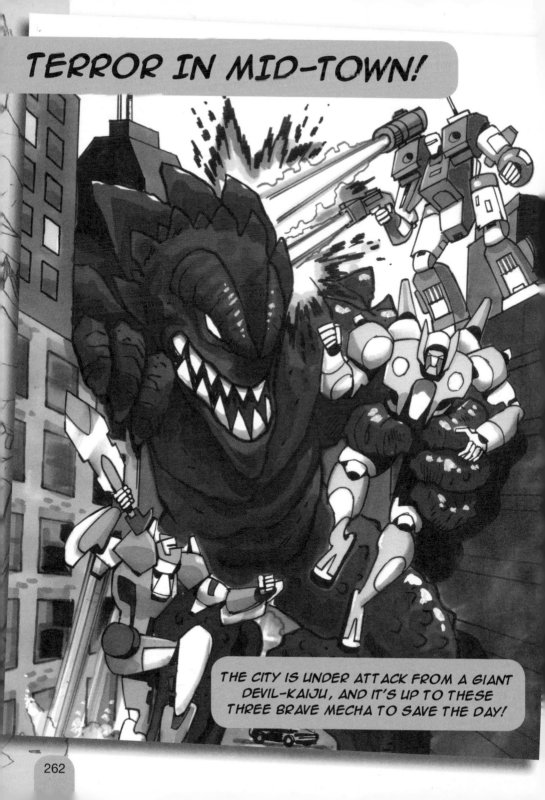

TERROR IN MID-TOWN!

THE CITY IS UNDER ATTACK FROM A GIANT DEVIL-KAIJU, AND IT'S UP TO THESE THREE BRAVE MECHA TO SAVE THE DAY!

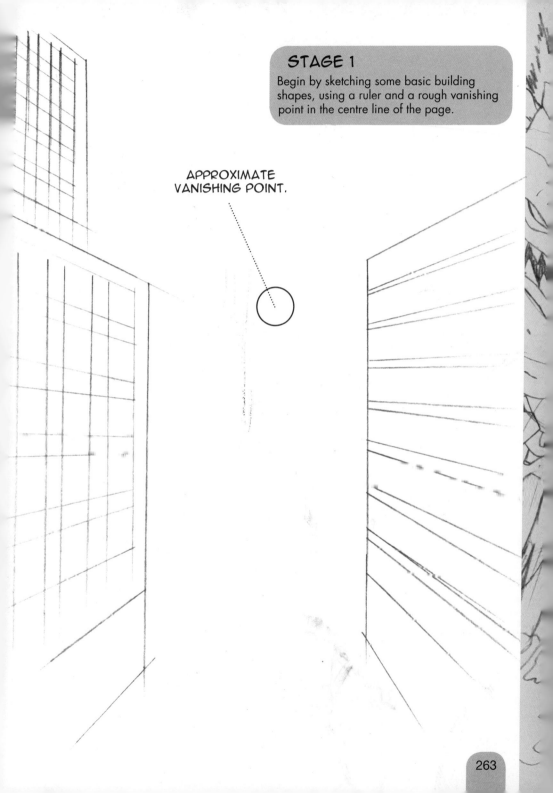

STAGE 1

Begin by sketching some basic building shapes, using a ruler and a rough vanishing point in the centre line of the page.

APPROXIMATE
VANISHING POINT.

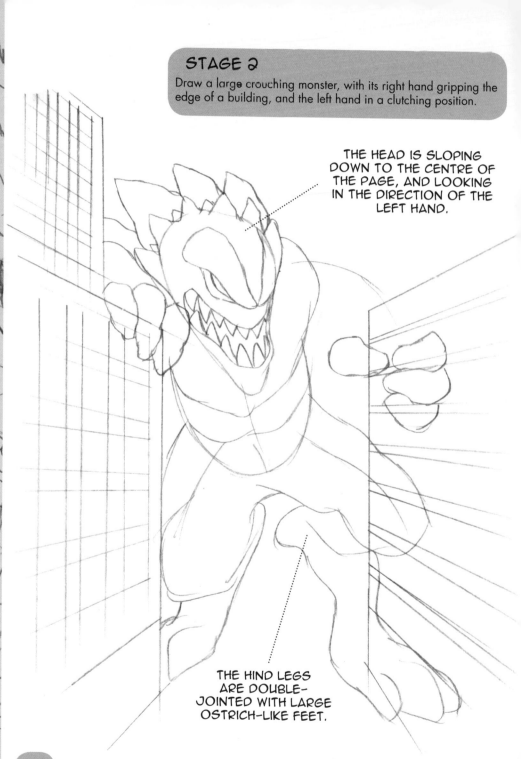

STAGE 2

Draw a large crouching monster, with its right hand gripping the edge of a building, and the left hand in a clutching position.

THE HEAD IS SLOPING DOWN TO THE CENTRE OF THE PAGE, AND LOOKING IN THE DIRECTION OF THE LEFT HAND.

THE HIND LEGS ARE DOUBLE-JOINTED WITH LARGE OSTRICH-LIKE FEET.

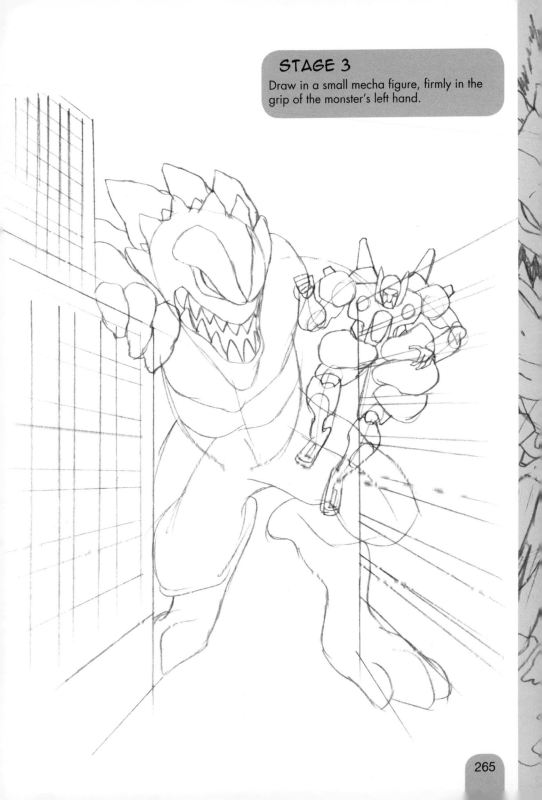

STAGE 3

Draw in a small mecha figure, firmly in the grip of the monster's left hand.

STAGE 4

Next, add two more mecha figures, one firing down from the rooftops and one blasting up from the street with a mecha-type sword.

STAGE 5

Add further details, including a further couple of building tops in the background, and a burning car to give scale. Litter the street with rocks to show a battle is in full swing.

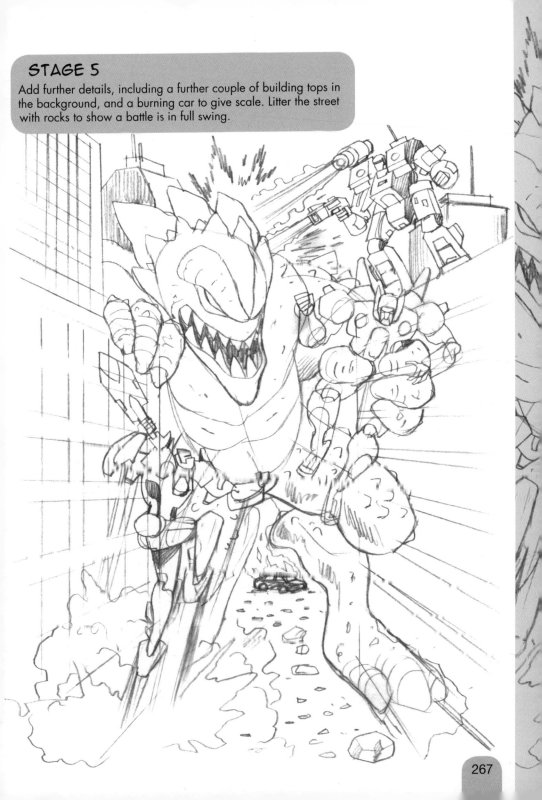

STAGE 6

Ink and colour your monster in red, and use bright colours for the mecha. Make the buildings dark grey, which will draw the eye to the bright colours of the figures.

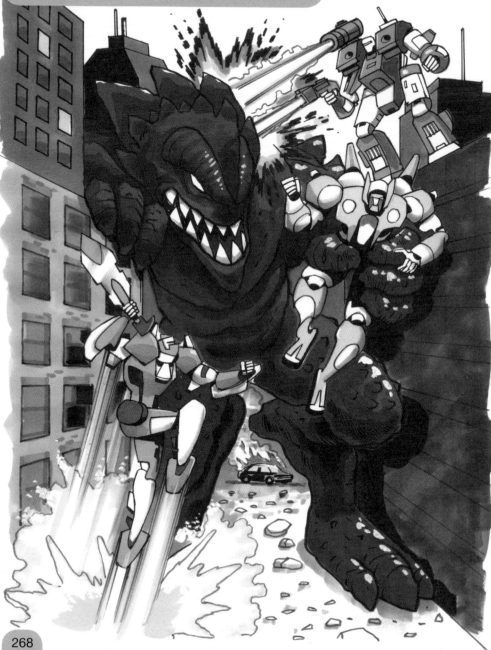

STAGE 7
Build up shadows with repeated application of dark grey markers, then use some white paint and black ink to give your illustration extra contrast.

WATERY STRUGGLE!

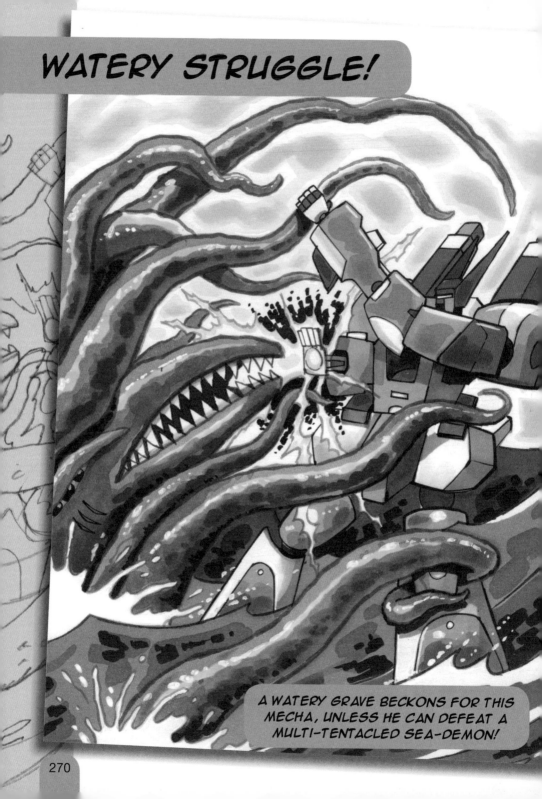

A WATERY GRAVE BECKONS FOR THIS
MECHA, UNLESS HE CAN DEFEAT A
MULTI-TENTACLED SEA-DEMON!

STAGE 1

Start by drawing a series of lines representing waves at the bottom half of the page. The highest one should be more or less horizontal, and the ones in the foreground at a steep angle.

STAGE 2

Draw a wireframe mecha figure on the right of the page, with his feet submerged in the water. The left arm is raised at an angle with the hand in a gripping shape, and the right arm is folded back at the elbow, with a straight forearm and hand palm up.

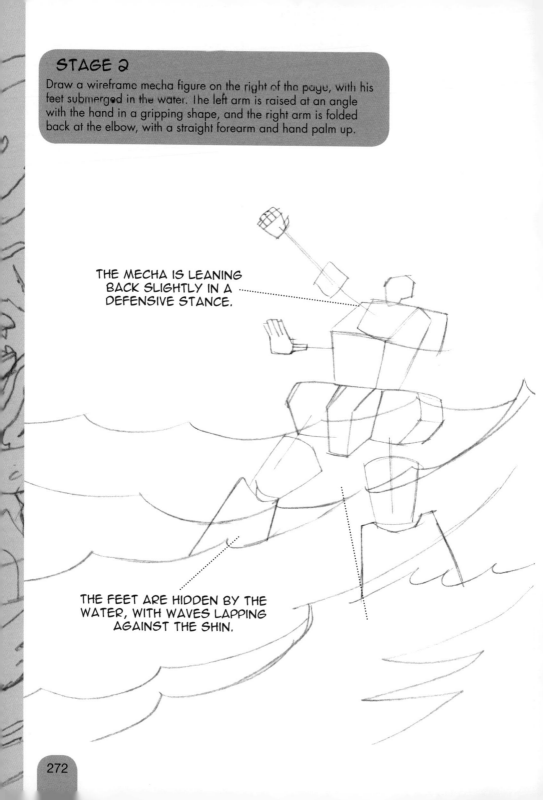

THE MECHA IS LEANING BACK SLIGHTLY IN A DEFENSIVE STANCE.

THE FEET ARE HIDDEN BY THE WATER, WITH WAVES LAPPING AGAINST THE SHIN.

STAGE 3

Add vertical shoulder jets and lots of panel shapes and fins to your mecha armour.

STAGE 4

On the left side, draw a monstrous head curving up toward the figure. Use a dolphin-like shape with long thin mouth and rows of razor-sharp teeth. Add a triple-eye and three small gills.

THE CURVE OF THE MONSTER'S HEAD SUGGESTS A DIRECT LINE OF MOVEMENT TOWARDS ITS PREY.

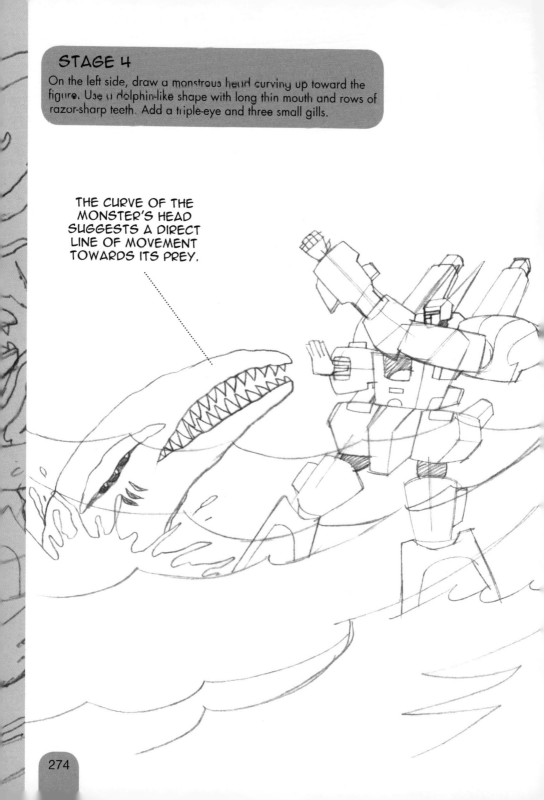

STAGE 5

Add powerful-looking tentacles snaking from the water, attacking the mecha. Make one tentacle pass through the gripping hand, and in the other hand draw a blast of repulsor electricity, which the mecha is using to try and stun the beast.

USING AN ELECTRIC PULSE IN THE WATER IS A DANGEROUS TACTIC, BUT A GOOD MECHA SUIT LIKE THIS IS FULLY INSULATED AGAINST ELECTRICAL SHOCK.

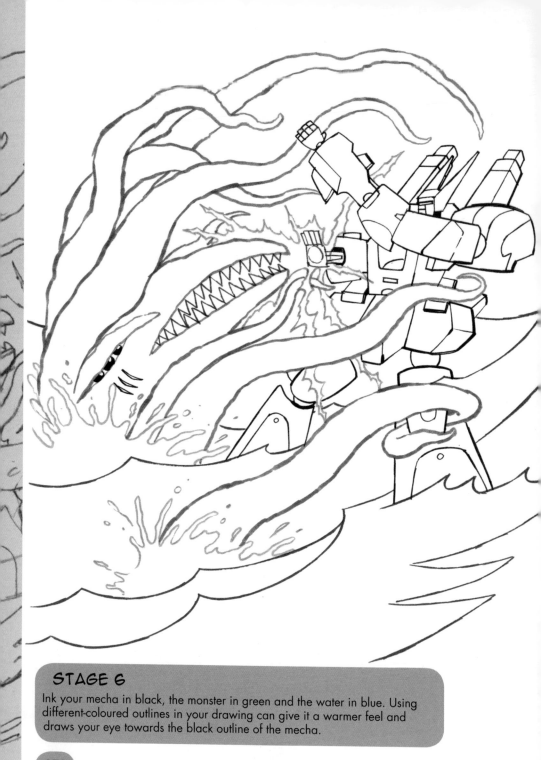

STAGE 6

Ink your mecha in black, the monster in green and the water in blue. Using different-coloured outlines in your drawing can give it a warmer feel and draws your eye towards the black outline of the mecha.

STAGE 7

Colour your drawing with blue, green, mauve and lilac. Use a dark green and some white paint to add depth to the tentacles, and paint some splashes of white sea spray on the water. Add some black brushpen marks to the water surface.

SURROUNDED!

THIS FEMALE CYBORG IS SURROUNDED BY VORACIOUS CRAB MUNCHERS. HER ONLY CHANCE IS TO USE HER POWER-CHARGED BIONIC FIST!

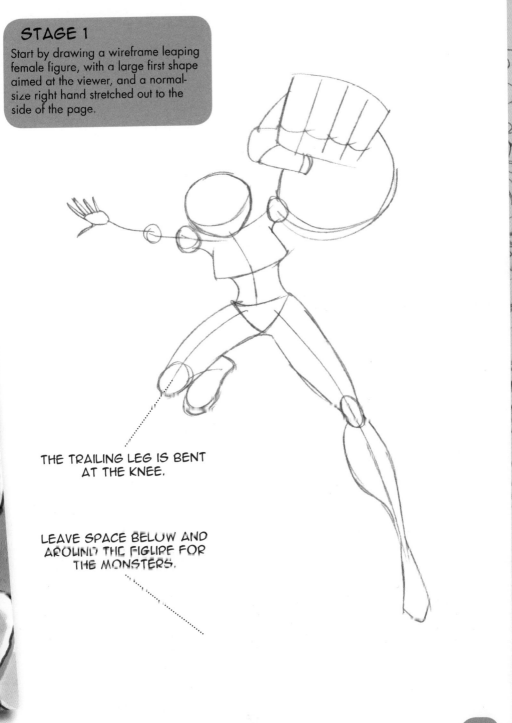

STAGE 1

Start by drawing a wireframe leaping female figure, with a large first shape aimed at the viewer, and a normal-size right hand stretched out to the side of the page.

THE TRAILING LEG IS BENT
AT THE KNEE.

LEAVE SPACE BELOW AND
AROUND THE FIGURE FOR
THE MONSTERS.

THE SKIRT IS PLEATED
AND BILLOWING OUT
AT THE SIDES TO
SHOW MOVEMENT.

STAGE 2

Add detail to the head, hair, torso and
skirt as shown. Have the hair trailing off
to the side of the head in a long pony tail.

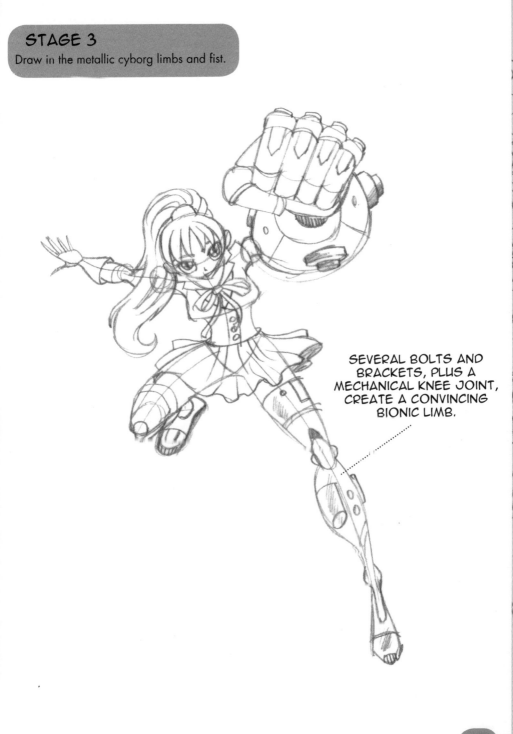

SEVERAL BOLTS AND
BRACKETS, PLUS A
MECHANICAL KNEE JOINT,
CREATE A CONVINCING
BIONIC LIMB.

STAGE 4

Draw a series of irregular circles at varying sizes beneath and around the figure, with the largest in the foreground underneath the left leg.

STAGE 5

Add some spiky crab legs and spikes to the monster bodies, and show some circular mouth openings studded with small, sharp teeth. Draw an electrical halo around the fist.

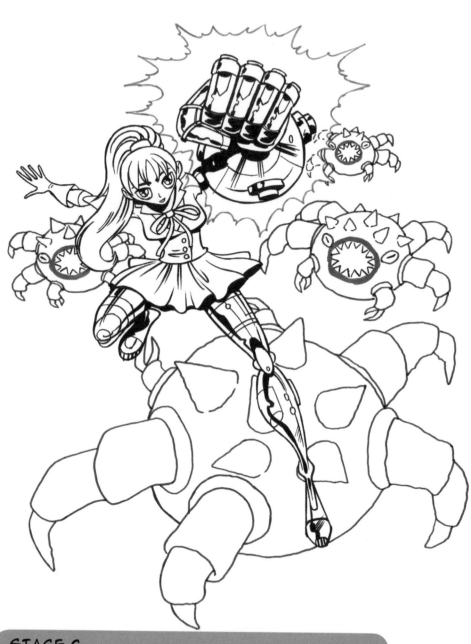

STAGE 6

Ink your drawing using black lines for the figure, along with strong shadows to suggest a metallic effect. Use a blue line for the electrical charge, and a brown outline for the monsters, with a red lip line around the mouths.

STAGE 7

Colour your monsters in brown and warm grey. Use a yellow for the electrical charge and a pale blue/grey mix for the cyborg limbs. Make the hair a bright colour to stand out, with a splash of red on the bow.

INDEX

ACKNOWLEDGEMENTS

Thanks to Edd Ralph at Search Press for his expert encouragement and assistance in producing this book; to my wonderful sons Joe Sparrow and Frank Sparrow for constantly inspiring me to get better at what I do; to all my lovely friends in Cornwall, London and beyond for making life spiffy; to all the fantastic mangaka who attend the workshops and Ato-Gami sessions and keep me on my toes; to Sarah, Andrew and everyone at Waterstones in Truro for their support.

You are invited to visit:
www.kaspar.co.uk
http://keefsparrow61.tumblr.com
www.facebook.com/keith.sparrow.1232